Within this Garden

Photographs by Ruth Thorne-Thomsen

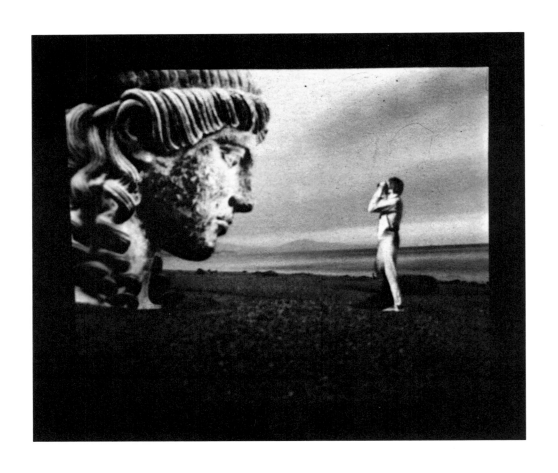

Within this Garden

Photographs by
Ruth Thorne-Thomsen

Denise Miller-Clark

With a Poem by Mark Strand
Edited by Terry Ann R. Neff

The Museum of Contemporary Photography
Columbia College Chicago

Aperture

Within this Garden: Photographs by Ruth Thorne-Thomsen was prepared on the occasion of the exhibition of the same name originated by The Museum of Contemporary Photography, Columbia College Chicago, and on view there from April 3 through May 29, 1993. The exhibition will tour in the United States and abroad.

The Museum of Contemporary Photography was founded by Columbia College Chicago in 1984 to exhibit, collect, and promote contemporary photography. The outgrowth of the Chicago Center for Contemporary Photography, established by the college in 1976, it remains the only museum in the Midwest with an exclusive commitment to the medium of photography. Accredited by the American Association of Museums, The Museum of Contemporary Photography is the result of the long-standing reputation that Columbia College Chicago enjoys as an institution that provides the public with superior programs in the teaching and exhibiting of photography. Each year the museum presents a wide range of provocative, innovative exhibitions in recognition of photography's many roles: as a medium of communication and artistic expression, as a documenter of life and the environment, as a commercial industry, and as a powerful tool in the service of science and technology. Programs of the museum include a permanent collection of contemporary American photography and a print study room; educational services such as lectures and panel discussions, video and film presentations; membership benefits; a museum studies program sponsored by the Columbia College Chicago Department of Photography; publications; and traveling exhibitions originated by the museum.

Aperture Foundation, Inc., publishes a periodical, books, and portfolios of fine photography to communicate with serious photographers and creative people everywhere. A complete catalogue is available upon request from Aperture, 20 East 23rd Street, New York, New York 10010.

ISBN 0-89381-549-7 (clothbound)
ISBN 0-932026-30-3 (paperbound)

Library of Congress Catalogue Number 93-070464

Edited by Terry Ann R. Neff, T.A. Neff Associates, Chicago
Designed by Michael Glass Design, Inc., Chicago
Typeset in Univers Extended by Paul Baker Typography, Inc., Evanston, Illinois
Printed by Becotte & Gershwin, Horsham, Pennsylvania
Bound by Horowitz/Rae, Fairfield, New Jersey

Cover: *Messenger #1, Pennsylvania,* 1990 (cat. 81), detail
Frontispiece: *Photographer, California,* 1981 (cat. 25)

Contents

Preface and Acknowledgments

By Denise Miller-Clark

Within this Garden presents the work between the years 1976 and 1992 of the contemporary American photographer Ruth Thorne-Thomsen. It is the first monograph on this compelling artist and accompanies a mid-career traveling retrospective that includes her 4-by-5-inch and mural images from six series: *Expeditions, Door, Prima Materia, Views from the Shoreline, Messengers,* and *Songs of the Sea.* I am particularly pleased to include an original work by Poet Laureate Mark Strand, whose poem is reflective of the sympathetic relationship he feels between his writing and the artist's photographs.

Influenced by rich and diverse canons, movements, and precepts in art, culture, history, literature, mythology, philosophy, and psychology, Thorne-Thomsen has created an incredibly imaginative oeuvre. Hence, the following essay focuses not only on the technical construction of her photographs, but particularly on the symbolism in her imagery. The title for this publication and the exhibition, devised by the photographer, is purposely ambiguous. The garden is often used as a metaphor for a closed but encyclopedic system. Garden designs display a variety of ordered structures, but also relate directly to man's ability to manipulate nature. For Thorne-Thomsen, the garden is a profound symbol: a center full of mystery, a philosophical space, a temple, a marvelous image for life. It represents a place of integrity where beings, creatures, and matter are respected in their natural or current state; for the photographer, the title alludes to the "Self" attempting to achieve integration, actualization, and harmony.

One of the great pleasures in preparing the exhibition was the opportunity for many meetings and conversations with Ruth Thorne-Thomsen. I first met the artist in 1980, when I came to Columbia College Chicago where she was on the faculty. My understanding of her photographs over the years has been enhanced and shaped by her most recent ideas about the creation of her images. I am grateful for her generosity of both spirit and time.

In formulating the exhibition and my essay, I found discussions with many individuals to be helpful. I especially would like to thank Harold Allen, Shashi Caudill, Mary Dougherty, Carol Ehlers, Olivia Gonzales, Stephanie J. Graff, Ray K. Metzker, Laurence Miller, John Mulvany, Terry Ann R. Neff, Charles Reynolds, Jorge Schneider, Caroline Stevens, Katherine Taylor Loesch, Ellen Ushioka, and a few collectors who wish to remain anonymous. Their commentary clarified points in my writing and supplied many important supportive examples.

Terry Neff is also to be commended for her steadfast patience and sharp intellect as publication manager and editor. She brings order, clarity, and grace to the book. I applaud

Michael Glass for his elegant catalogue design. Michael Becotte and Chuck Gershwin have shown considerable dedication to the challenging task of printing this book. Michael Hoffman, Michael Sand, and Melissa Harris at Aperture deserve special thanks for their support and assistance on the publication, produced under a rigorous timetable.

Virtually the entire staff of The Museum of Contemporary Photography and many departments of Columbia College Chicago at one time or another felt the pressures of *Within this Garden: Photographs by Ruth Thorne-Thomsen.* The realization of the project would have been unthinkable without the smooth, committed cooperation of a great many people. I wish in particular to thank Stephanie J. Graff, Museum Graduate Intern, for her tireless contributions in assisting me with research. Her attention to detail in preparing Thorne-Thomsen's biographical data and title descriptions, and in carrying out the myriad responsibilities of preparing the manuscript and educational packet for numerous reviews and final production, was exemplary. Paula Epstein, Reference Librarian, Keith DeWeese, Circulation Librarian, and the general library assistants and interns at Columbia College Chicago were most helpful in garnering for reference the necessary books and periodicals from around the country. Stephanie J. Graff and I are most grateful for their excellent service. I would also like to commend Assistant Director Ellen Ushioka, Preparator and Curatorial Assistant Jennifer Hill, Traveling Exhibitions Coordinator and Curatorial Assistant Martha Alexander-Grohmann, and all museum interns who were instrumental in formulating funding proposals, conducting fact-finding research, and preparing the exhibition for presentation in Chicago and subsequent tour in the United States and abroad. To that end, I also thank Thomas Nowak and William G. Frederking for their production of the accompanying slide transparencies, copy, and installation photographs. I am grateful to all for their unstinting devotion to standards of excellence.

The exhibition and publication programs of The Museum of Contemporary Photography have been enthusiastically supported by John Mulvany, Chairman of the Museum Governing Board, President John B. Duff, and Provost and Executive Vice President Albert C. Gall of Columbia College Chicago, and the college's Board of Trustees. I value their high regard for our programming and thank them for their professional and financial contributions, as well as those of other support administrators, including R. Michael DeSalle, Vice President of Finance; Nicholaas Van Hevelingen, Vice President of College Relations and Development; Gregory Salustro, Director of Development; Carol Bryant, Director of College Relations; and Mary Spagnolo of the Office of College Relations.

The publication of this book and the preparation of the traveling exhibition were aided by donations and grants to The Museum of Contemporary Photography from numerous individuals and organizations. In particular, I would like to thank the staffs and museum program panel reviewers for the National Endowment for the Arts, the Institute of Museum Services, and the Illinois Arts Council for the award of grants. I am also appreciative of the funding from Ruth Thorne-Thomsen's representative galleries: Ehlers Caudill, Ltd., Chicago; Laurence Miller, New York; Jessica Berwind, Philadelphia; Jan Kesner Gallery, Los Angeles; Robischon Gallery, Denver; and Jon Oulman Gallery, Minneapolis; funding from private donors and foundations: James J. Brennan, Brennan Steel, Northfield, Illinois; David C. and Sarajean Ruttenberg and the Ruttenberg Arts Foundation, Chicago; Michael Glass and Ann M. Rothschild, Chicago; and contributed products and services from Eastman Kodak Company, Photographic Products Group, Rochester, New York; Crescent Cardboard Company, Wheeling, Illinois; Fancy Colours and Company, Schaumburg, Illinois; and Callihan & Melville Fine Framing, Central Camera Company, Comco Plastics Inc. of Illinois, Division of Commercial Plastics & Supply Corporation, Design Color Imaging, Henry Hampton, Inc., LaSalle National Bank, Midland Paper, Peterson Picture Frame Company, Inc., Ross-Ehlert Photo Labs, and Terry Dowd, Inc. in Chicago.

To my family, especially my husband, John R. Clark, my friends, and most importantly Ruth Thorne-Thomsen, all of whom have endured my high and low emotions on the project, borne with me through considerable sacrifices made to move it toward completion, and given wise and valuable counsel, I extend my most sincere thanks.

Denise Miller-Clark
Director
The Museum of Contemporary Photography

The Quest:
Marvelous Sites and a Wondrous Journey

By Denise Miller-Clark

Ruth Thorne-Thomsen is an explorer. Since 1976 she has been on a quest to explore unknown territory, a world of an ancient past constructed through the imagination of the photographer — an archaeology of the spirit. Her journey involves a twofold path: a social course in which she records memories of a collective unconscious and a biological track in which she seeks her psychic nucleus. Herein, her work is difficult to pinpoint historically. It has been classified within the recent mode of photography as performance, theater, or stage set, as exemplified by the work of the American photographers featured in the 1989 exhibition and publication *The Photography of Invention: American Pictures of the 1980s*.[1] These photographers stage works either with elaborately constructed narrative tableaux; appropriated imagery from film, television, and print media; stylized role play; or multiple, serial imagery to suspend or expand time. In the same vein as these photographers, Thorne-Thomsen creates space, figure, and object relationships that arrest moments from the rhythm of reality. Unlike them, she constructs historical landscapes based on antiquity (even the photographs in her series *Messengers* become flat in their abstraction). Essentially, Thorne-Thomsen's photographs are liberated assertions of the unconscious realm, a realm that provides material for dreams that are mysterious, symbolic, and common to all mankind. These are archetypal works in the Jungian operative: not form or figure, but image within human spirit. Since 1981, when she began to use psychoanalysis to come to a better understanding of her work, Thorne-Thomsen has been involved with the dynamics of the illusions that give rise to symbols in what Carl Gustav Jung (Swiss, 1875–1961) refers to as the "collective unconscious."

> Everything, indeed, is at least twofold.[2]
> Marcel Proust

In *The Magic Lantern of Marcel Proust*, Howard Moss marvelously unfolds Proust's continuous eight-part novel *A La Recherche du temps perdu* (*Remembrance of Things Past*), "a biography of a novelist written by its subject, who has decided to write a novel instead of an autobiography, and whose only novel is the biography he is writing."[3] In the story, "Marcel" explores two visions of life's possibilities — the "Méséglise way" (the biological approach) and the "Guermantes way" (the social route) — on the one hand, directions, progressions, journeys; on the other, modes of living.[4] It is a perfect paradigm for exploring the quest of an artist, in particular the photographer Ruth Thorne-Thomsen, because at every turn her path is twofold — as much inner journey as creative production. Her travels and her

art are so closely linked that her photographs may be viewed in part as a deeply personal visual diary. But although her creative ideas, vision, and process are reflected in this essay, viewers are not locked into an analysis based on the artist's understanding. Rather, the images provide a poetic point of departure for individual interpretation.

Thorne-Thomsen has said that her aim as an artist is to create or provoke, if even for a moment, a sense of wonder. In her pursuit she has uncovered much about her center, her psychic nucleus, her "Self." During her lifelong journey toward integration, she has created many marvelous sites. As a perpetual traveler, sophisticated designer, consummate experimentalist, and imaginative poet, Thorne-Thomsen has mined the inner universe of the psyche to create an oeuvre filled with images that are compelling, indeed archetypal. It is often remarked that Thorne-Thomsen's photographs evoke a sense of condensed history. Her works manage to blend the heroic simplicity of antiquity, the ecclesiastical allegory of the fifteenth century, the romantic vision of the nineteenth century, and the Surrealistic aspects of the twentieth. She draws from rich and diverse sources of inspiration, such as the prehistoric dolmens and menhirs of Celtic Britain, the hermae boundary stones of early Greece, the art and architecture of ancient Egypt, the paintings of Renaissance Tuscany (see fig. 1), the royal gardens of France and Baroque Italy, the prints of nineteenth-century

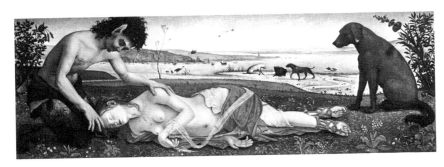

Fig. 1. Piero di Cosimo, *A Satyr Mourning Over a Nymph*, c. 1487.
Unprimed wood painted surface,
23¾ x 72¼ inches.
Reproduced by courtesy of the Trustees,
The National Gallery, London.

British and French expeditionary photographers, the tin *retablos* of fifteenth-century Spain and nineteenth-century Mexico, the Hispanic wooden *santos* made in New Mexico and Colorado in the late nineteenth and early twentieth centuries, the paintings of the Symbolists, the writings and collages of the Surrealists, and myths, folktales, legends, poetry, and psychology. Yet Thorne-Thomsen transforms these historical referents, filtering them through her individual sensibility. A curious and eclectic mix of intellect and innocence despite their artifice, the photographs trigger a sense of memory in the viewer. While many of the forms and figures in her pictures suggest antiquity, the pyramids, columns, obelisks, and monoliths are repetitive symbols, archetypes found today in art, literature, architecture, and nature. Hence, not only do Thorne-Thomsen's photographs explicate meaning, they explore contracted time and space. Like Proust, Thorne-Thomsen uses figuratively both the "microscope" and the "telescope" (often considered marvels in themselves) as instruments of perception, for "the microscope and the telescope share in common lenses of magnification. The first deals with the invisibly small; the second with the invisibly distant. As such, the first is an instrument of space, the second an instrument of space-time...through which we look up at the stars, the forgotten years that lie behind, or the unsuspected years that

stretch ahead of any moment though the perceiver may not be aware of it when it is occurring."[5] As the present interprets the past, the past constructs the present.

Using an instrument first suggested by Chinese philosophers, developed by Greek astronomers to observe eclipses, sunspots, and planetary movements, and adapted during the Renaissance as an aid to drawing, Thorne-Thomsen worked from 1976 until 1984 with a portable version of a camera obscura. Translated literally as "dark room," the camera obscura effects an image that is formed by light passing through a small hole into a darkened chamber and falling onto the opposite wall. During the seventeenth century, artists wishing

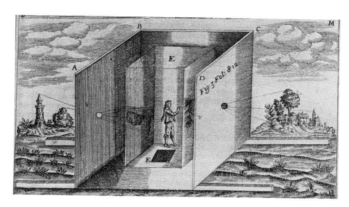

Fig. 2. Athanasius Kircher, *Large Portable
Camera Obscura*, 1646.
Engraving, 3¾ x 6½ inches.
Gernsheim Collection, Humanities Research Center,
University of Texas, Austin.

to produce landscapes of impeccable alignment would cut a small hole in the wall of a darkened room adjacent to the scene they wished to reproduce. Sunlight passing through the puncture projected onto the opposing wall an inverted and reduced image of the scene which could be traced to form the skeleton for a drawing or painting (see fig. 2). A box can perform a similar function. Indeed, in the late 1830s, the earliest "photographers" would fit

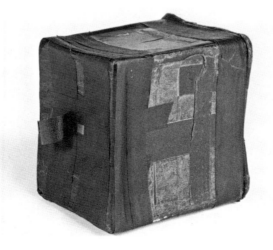

Fig. 3. Ruth Thorne-Thomsen's Pinhole Camera, 1975.
Crescent board, black photographic tape,
and brass shim, 5 x 4 x 5¼ inches.
Collection of Ruth Thorne-Thomsen.
Photograph by Thomas Novak.

their dark boxes with lenses and insert daguerreotype plates glazed with chemicals and etched by the light of the sun to render the natural world like a mirror. Precise definition was the hallmark of the invention of photography. In the 4-by-5-by-6-inch cardboard box that Ruth Thorne-Thomsen carried (fig. 3), however, images were projected through a needle-sized opening, or *aperture* as it is referred to photographically, in one side of the "camera" and received by a black interior lined at the back with 4-by-5-inch light-sensitive paper. These "negatives" would be developed for about a minute-and-a-half and contact-printed as final works with the distinctions of *pinhole* optics: a vignetted image with softened focus and near infinite depth of field that is reflective of emotional tone and expressive of dream-like solitude and timelessness. It is both ironic and appropriate that Thorne-Thomsen chose photography, with its celebrated attributes of definition and clarity, to construct landscapes of the psyche. With no other medium could she rely on such veracity to make an unknown territory like the unconscious appear tangible.

The camera obscura was a liberating tool for Thorne-Thomsen. It was portable, free of mechanical failure, and clearly inexpensive, so she had no fear of loss or theft. Most important, however, it had no viewfinder, so photographing became an exercise of the imagination; one could only wonder how the camera would interpret the scenes. Maneuvering around on the water's edge, for the vantage point was invariably the ground, the photographer was occasionally an attraction for onlookers (although she often sought out places with few observers), but she was totally absorbed in her *play* and the dazzling perspectives of her worm's-eye view. It is this "exercise of the imagination" and viewpoint that further position Thorne-Thomsen with many of the tenets of the Surrealist movement—experimentation, randomness, a poeticism associated with chance, a collage aesthetic with odd yet remarkable juxtapositioning—in addition to deep respect for scientific method, with particular interest in psychology and the unconscious. She often speaks of her photographic experiences as periods of "letting go" and times when images "created themselves."

In preparation for a companion book to the celebrated PBS television series "Creative Spirit," the originators, Daniel Goleman, Paul Kaufman, and Michael Ray, described the encounter with a "white moment" by athletes, performers, artists, lovers—virtually anyone engaged in the full fire of creativity: "Everything clicks. Your skills are so perfectly suited to the challenge that you seem to blend with it. Everything feels harmonious, unified, and effortless."[6] The renowned psychologist Mihalyi Csikszentmihalyi calls that white moment *flow*—"the state in which people are so involved in an activity that nothing else seems to matter."[7] Flow is connected to a loss of self-consciousness. For Ruth Thorne-Thomsen, these lucid moments are most conducive to the making of photographs, but they represent a state of mind that cannot be forced and is most difficult to attain. Flow can occur for her both in the studios in Philadelphia and Castle Valley, Utah, and on locations throughout the world where, listening to an inner voice, she has collaged the landscape with figures, forms, and appropriated images. She laments, however, "As much as we long for these moments of illumination, they are elusive; for what seems to happen is disorientation, then the pragmatic intellect or the ego, striving to maintain equilibrium, kicks in and neutralizes the moment by trying to analyze or explain it."

Thorne-Thomsen describes periods or surges of creative energy when pictures are made with all the physical skills one needs to make a photograph, but skills now in the service of something, or someone, else, urging combinations of props and photographs. Unconsciously, she is drawn to the possibilities; she interacts with them, new connections are made, and scenes are photographed. A *conscious* interaction with the images does not

begin until the works are exposed, then an exchange ensues, and the artist learns something. In the most successful photographs, objects, images, and the landscape attract as if by magnetic force. It is no wonder that she comments, "It may be ridiculous for the photographer to take credit for the pictures, for it is the collective strength of wisdom from previous generations that affirms the moment to click the shutter." While some images are partially previsualized, she always allows for spontaneity (another Surrealist doctrine).

Spontaneity, originality, and creativity were nurtured in Ruth Thorne-Thomsen. From 1961 until 1963, she studied dance at Columbia College in Columbia, Missouri, and painting at Southern Illinois University in Carbondale from 1966 until 1970, when she received a Bachelor of Fine Arts degree. Her education gave her techniques, sharpened her skills, and expanded her mind, but gradually she discovered that an even greater resource had been instilled during a much earlier time. The sense of wonder with which Thorne-Thomsen seeks to imbue her pictures is found most potently in the minds of children, whose vision is nearer to the threshold of the imagination. Like the Surrealists, the photographer places a premium on the sovereignty of infancy, seeking to recapture its magic in her work. In the words of Bill Brandt (British, 1906–1983), a renowned figure of twentieth-century photography whose works Thorne-Thomsen admires, "It is part of the photographer's job to see more intensely than most people do. He must have and keep in him something of the receptiveness of the child who looks at the world for the first time or of the traveller who enters a strange country."[8]

Thorne-Thomsen's past was influenced by an aesthetic and literary heritage. Although her entire family was encouraging, one person impacted her life greatly. Ruth Spaulding Edwards, the photographer's maternal grandmother, was interested in history and travel. She and her husband made annual excursions to different corners of the world, in particular, the Mediterranean, especially Greece and the Dalmatian coast of Yugoslavia.

Fig. 4. Ruth S. Edwards, *Ding and Brownie*, 1918.
Silver gelatin print, 6¹¹⁄₁₆ x 9¹⁵⁄₁₆ inches.
Collection of Ruth Thorne-Thomsen.

A voracious reader and skilled amateur photographer, Ruth Spaulding Edwards recorded her travels and the minutiae of her family's life. Her daughter, Mary Blanchard Thorne-Thomsen, writes that in her environment, photographs were a "commonly accepted and pleasurable part of life" (see fig. 4). "No matter what we were doing as a family — picnicking, setting out in the car, or just playing in the garden, there was usually a camera around." She too turned to photography. About her own picture-taking abilities, she added:

> Turning to my own pictures...what I am looking for myself — a phase of
> family life that I always wanted and still want to record is habitual experi-

ence. For instance, when our children were young a part of our evening before-bed ritual was to play records, sing and dance. It was a lovely time More recent rituals, particularly during the summer months at Gills Rock, center around the preparation for bicycle-riding.... Many, many pictures record our daily gathering at the dock for a swim and all the diving, sunbathing, etc. connected with that important activity; and the whole ritual of readying a row boat for fishing or a motor boat for chasing out into the Bay to meet an ore boat. Every picnic of the summer is duly recorded as are many gatherings about the telescope to watch one of the big ore carriers go through Death's Door...and I try to record arrivals, if possible, and almost always partings. Those are moments when emotions often show.[9]

The exhibition catalogue *Mother & Daughter: A Family Album by Ruth Edwards and Mary Thorne-Thomsen* reproduces the family collection of pictures taken by both Ruth Thorne-Thomsen's mother and grandmother. "Missie," as her grandchildren called her, became a "soul mate" for Thorne-Thomsen and would later be referenced in her work, for example, in *Geometric Lady* from the series *Expeditions* (pl. 29), and in *Harlequin Head, Turrita Mater,* and *Thunderhead,* from *Views from the Shoreline* (pls. 57, 62, 63). She influenced the artist's interest in history, travel, Greek mythology, and symbols, among other topics, and was responsible for starting her formal studies of photography. A small inheritance from Missie enabled Thorne-Thomsen to purchase a 35mm Pentax and to take a trip to the Alaskan Arctic in 1971, just as civilization was about to encroach upon that landscape with the construction of the Trans-Alaska Pipeline. It also made it possible for her to begin her undergraduate work in photography that same year at Columbia College Chicago, and complete there in 1973 a second Bachelor of Arts degree.

At Columbia and in the early years of her graduate studies at The School of The Art Institute of Chicago, the artist used a single-reflex camera, which, unlike the pinhole, was designed to imitate human vision and perspective. She often worked with infrared film and motion, however, both involving elements of the unknown (see fig. 5). Unconsciously, these works started her on her journey.

Fig. 5. Ruth Thorne-Thomsen, *Untitled,* 1973.
Silver gelatin print, 8⅞ x 12⅞ inches.
Courtesy of the artist.

When you start on your journey to Ithaca,
then pray that the road is long,
full of adventure, full of knowledge.
Do not fear the Lestrygoians
and the Cyclopes and the angry Poseidon.
You will never meet such as these on your path,
if your thoughts remain lofty, if a fine
emotion touches your body and your spirit.
You will never meet the Lestrygoians,
the Cyclopes and the fierce Poseidon,
if you do not carry them within your soul,
if your soul does not raise them up before you.

Then pray that the road is long.
That the summer mornings are many,
that you will enter ports seen for the first time
with such pleasure, with such joy!
Stop at Phoenician markets, and purchase fine merchandise,
mother-of-pearl and corals, amber and ebony,
and pleasurable perfumes of all kinds,
buy as many pleasurable perfumes as you can;
visit hosts of Egyptian cities,
to learn from those who have knowledge.[10]

C.P. Cavafy

Ruth Thorne-Thomsen began *Expeditions*, her most extensive series, in 1976 while she was completing her Master of Fine Arts degree at The School of The Art Institute of Chicago. The first images were of lands of heat, mystery, and romance. The sand castles, pyramids, and palm trees in her photographs hint at exotic places just beyond the frontiers of civilization, even though the miniature landscapes were made on the heavily populated beaches of California and Mexico. The series title, a metaphor for those passions instilled by her maternal grandmother, also suggests adventure.

It is this early work that was most influenced by the 1849 archaeological surveys in the Near East of Maxime Du Camp (French, 1820—1894) and the 1856 photographic tours to the Middle East of Francis Frith (British, 1820—1899). Du Camp was a popular and prolific travel writer and journalist who, like Thorne-Thomsen, worked with paper negatives, his actually made in Egypt and the Holy Land. He and many other wealthy French and British businessmen, physicians, scientists, journalists, explorers, and men of leisure were hired by publishers such as Louis Désiré Blanquart-Evrard (French, 1802—1872), who started in Lille the Imprimerie Photographique, the first successful photographic printing plant employing a substantial labor force. During the firm's eleven years of existence, it processed prints for dozens of publications.[11] Du Camp's works appeared in Blanquart-Evrard's first publication, *Egypte, Nubie, Palestine et Syrie* (1852).[12] More than a century later, fascinated by the kind of images found in this book, the entourage of porters and assistants, the travelers' tales, the magnitude of the effort required to obtain a permanent record of such cryptic and alluring locales, Ruth Thorne-Thomsen appropriated Du Camp's *Abu Simbel Colossus from the*

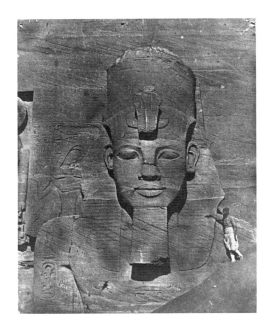

Fig 6. Maxime Du Camp, *Abu Simbel Colossus
from the Façade of the Temple of Ramses II*, 1850.
Calotype, 8¹⁵⁄₁₆ x 6⁹⁄₁₆ inches.
John M. Wing Foundation of The Newberry
Library, Chicago.

Façade of the Temple of Ramses II, 1850 (fig. 6) for her work *Sphinx, Illinois*, 1979 (pl. 20). To this "fabricated landscape," she added plastic figures and palm trees, thus providing not only a contrast of scale (as did Du Camp's native assistant in his original picture), but the same power to provoke the viewer's sense of wonder.

Thorne-Thomsen sought to re-create in her own works the deep space in the exploratory photographs.[13] The two earliest *Expeditions* pictures, *Pyramid, California* and *Pyramid and Palms, California* (pls. 1, 2), both made in 1976, use the natural landscape with remarkable results. Working with the camera obscura given to her by a friend in graduate school, she took advantage of the peculiar character of pinhole photography: the needle-sized aperture in her camera, equivalent to f/333,[14] and no lens yield a nearly infinite depth of field. Exaggerated variations in scale and perspective can be achieved. Objects in the foreground of pinhole photographs take on mammoth proportion. For example, while the mound in *Pyramid and Palms* is about the size of a human foot, the palms are real Southern California trees often seen by the photographer while visiting her parents in Santa Barbara. After the production of this image, the possibilities of working with the existing panorama to *create* landscapes appeared endless. The ease of loading paper negatives, the quick picture-making process (only Polaroid materials yield faster results), the transformation of her subjects, the frequent surprises, and photographing so freely at the water's edge had great appeal for the photographer.

A major influence on these early photographs was Francis Frith, the nineteenth-century British photography publisher whose firm, F. Frith & Company, Reigate, processed and sold millions of albumen prints from wet-collodion glass-plate negatives for framing, album mounting, postcards, stereographs, and book illustrations.[15] Frith photographed the monuments of the Middle East much like Ruth Thorne-Thomsen "set" many of her landscapes: with delineating shadows "cast by a raking morning sun to reveal the form and surface ornament," and human figures, first to define scale, later as "picturesque counterpoints and small details in the overall compositions."[16] Interestingly, both photogra-

phers also utilized lenses with specially constructed apertures. Frith's special shutter with a flap arrangement for shooting landscapes was handmade by the pioneering lensmaker Andrew Ross (British, 1798–1859) in May 1856.[17] In 1984 Thorne-Thomsen constructed an aperture for the lens in her Graflex Super D camera, a gift from her companion, American photographer Ray K. Metzker (b. 1931), to achieve the same effects of depth of field as her pinhole camera.

Whereas Frith was "the paragon of the new breed...the intrepid photographer overcoming both physical danger and technical difficulty in capturing memorable images that were taken to be truthful representations of the world,"[18] Thorne-Thomsen is the "primitive,"[19] masterfully merging the real and the unreal to create a hyperreality of great authenticity while utilizing an early instrument and process of nineteenth-century photographers: Louis Jacques Mandé Daguerre (French, 1787–1851), Joseph Nicéphore Niépce (French, 1765–1833), and William Henry Fox Talbot (British, 1800–1877), who discovered the first paper negative process—the calotype. Unlike Frith, who hauled tent, trays, scales, cumbersome brass-bound cameras and tripods, large glass plates, bottles of developing fluids, and distilled water, Thorne-Thomsen carried only the small cardboard box and sensitized paper negatives that could be developed in minutes in the darkroom. Despite these differences, the two delight in sights of temples, sphinxes, pyramids, and tombs, and share an ability to imbue landscape with concealed narrative. The appeal in the latter was due in part to the contrast of scenes near home and in part to viewers' recall of their biblical and classical heritage.

Thorne-Thomsen was equally attracted to the expeditionary photographers' experience of adventure. Sighting for the first time the great monuments of the world must certainly have been exhilarating, as evidenced by Frith's commentary about the Great Pyramid and the Sphinx (fig. 7): "The day and hour in a man's life when he first obtains a view of 'The Pyramids' is a time to date from for many a year to come; his approaching, as it were, the

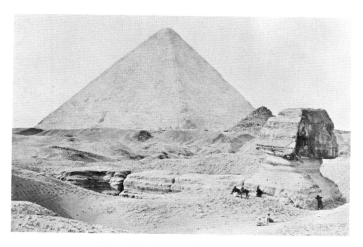

Fig. 7. Francis Frith, *The Sphinx and the Great Pyramid*, 1858.
Albumen print, 6¼ x 9 inches.
The Art Institute of Chicago Collection.

presence of an immortality which has mingled vaguely with his thoughts from very childhood, and has been to him unconsciously an essential and beautiful *form*, and the most majestic mystery created by man."[20] His words and the form itself, the staircase to heaven for pharaohs, took on important emphasis for Thorne-Thomsen. The mysterious and contradic-

tory emphasis, respectively, on the pyramid as symbolic of the earth in its maternal aspect and of death and immortality is reflected not only in *Expeditions*, but also in the photographer's subsequent three series, *Door*, *Prima Materia*, and *Views from the Shoreline*. Recognizing on a subconscious level in each of her series "essential and beautiful form" is the power of the symbolism in her work, and "the presence of an immortality which has mingled with thoughts from very childhood" corresponds directly to the concept of a "collective unconscious."

Coinciding with the early *Expeditions*, Ruth Thorne-Thomsen traveled to Mexico and California in 1976, to Death Valley with the photographer Judith Golden (American, b. 1934) in 1977, and again to Mexico in 1978 and 1980. On those excursions she recorded the landscape of sea and sand in Zihuatanejo, documented Mayan temples, made self-portraits (see fig. 8) and portraits of friends (see pl. 9) and people she met (see fig. 9). While the photographer discarded over the years many of these early efforts, the surviving works mani-

Fig. 8. Ruth Thorne-Thomsen, *Self-Portrait
with Seaweed, California*, 1976.
Toned silver gelatin print, 4 x 5 inches.
Courtesy of the artist.

fest two characteristics that foreshadow her later prints: the mystery of the ragged edge of the paper negative, and sepia toning that mimics the russet hues of the calotypes and albumen prints of the nineteenth-century explorers.

During 1976 and 1977, Thorne-Thomsen discovered the hallmark of her work, a collage aesthetic that continues to propel her today. The first *rencontre*[21] to employ a foreign object in the natural landscape, in this case a paper cutout, was *Building and Palms*, 1977 (pl. 8). It marked a significant turning point. Recognizing that the content of her pictures could be enhanced by appropriated photographs made "real" in the scene via the camera obscura's infinite depth of field, Thorne-Thomsen began to scour new and used bookstores and junk shops for imagery. Sources included travel, leisure, interior design, and architecture magazines; museum catalogues; and books on Greek and Roman antiquity. She

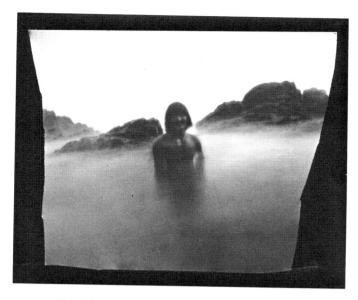

Fig. 9. Ruth Thorne-Thomsen, *Tino, Mexico*, 1976.
Toned silver gelatin print, 4 x 5 inches.
Courtesy of the artist.

would give herself "permission" to buy a book or periodical if it contained enough images that might be used in her work. Other times she would borrow books and photograph or photocopy sections of them, all the while building a formidable library of images. Always seeking reproductions that "resonate," she refers frequently to her proof sheets, a tremendous resource. "Anything that is strange, accidental, individual can become our portal to the universe. A face, a star, a stretch of countryside, an old tree, etc., may make an epoch in our inner lives."[22]

Eventually, in the late 1970s, the photographer would combine elements with the appropriated images, making surreal combinations. These props were essentially toys — small ornaments, children's charms, and objects she could carry in her pockets. In contrast to many other contemporary photographers who use inexpensive trinkets to explore the nature of illusionism, for example, David Levinthal (American, b. 1949), Allan McCollum (American, b. 1944), and Laurie Simmons (American, b. 1949), Thorne-Thomsen employs them to explore space, time, and meaning. Her first props were metal and plastic airplanes (on occasion, symbols for her younger brother Carl who was killed in the Vietnam War, other times a mode of entering, viewing, or escaping a scene; for Freud, a universally available sexual symbol). The number of items grew to include other gliders and dirigibles, reminiscent of the airships in the photographs of Jacques-Henri Lartigue (French, 1894–1986 [see fig. 10]). Many of the devices were purchased at dimestores in Chicago after her return from California where she had become more aware of what the pinhole camera could do. She has continued over the years to add to her collection with bulls from a souvenir shop, cowboys from a Chicago toy store, charms of a head and a silver shoe that she purchased in the Yucatan, the latter two featured in *Face at Tulum, Mexico*, 1978, and *Silver Shoe, Mexico*, 1978 (pls. 10, 11). With these objects she was successful in persuading viewers to accept on a poetic plane a relationship between normally distant realities, again a Surrealist canon.

The forms and figures in Thorne-Thomsen's photographs serve two functions: as symbols and scale models. Symbolism for esoteric thinkers is based on "the incontrovertible equation"[23] — macrocosm equals microcosm — perhaps the most philosophical aspect of

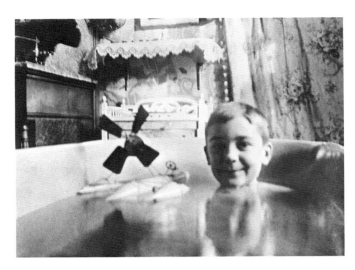

Fig. 10. Jacques-Henri Lartigue,
*Paris — 40 Rue Cortambert, Mon Hydroglisseur
à hélice aérienne
(My Hydroglider with Propeller)*, 1904.
Silver gelatin print, 7 x 9 inches.
Association des Amis de J.-H. Lartigue, Paris.

her work. Man is the world and the world is man. A Buddhist principle provides the perfect metaphor: in Zen the word *mind* is a symbol for consciousness of the universe. In fact, writes Kenneth Kraft, a Buddhist scholar at Lehigh University, "The mind of the individual and the mind of the universe are regarded as ultimately one. So by emptying oneself of one's smaller, individual mind, and by losing the individual's intense self-consciousness, we are able to tap into this larger, more creative, universal mind."[24] This connection is Thorne-Thomsen's aim as she struggles to work in flow with a feeling, objects, images, and their symbolism.

Emblems abound in her work. The pictures of airships, towers, heads, pillars, flying figures, chairs, and animals depict familiar yet strange objects and beings possessing specific connotations in addition to their conventional and obvious meanings. The horse, for example, is a complex symbol that has been characterized by humanists as "an attribute of Europe personified," an ancient symbol of "the cyclic movement of the world of phenomena," a more modern symbol for "intense desires and instincts," an omen of war and death, signifying wind and sea-foam, fire and light, a symbol of the cosmos, pertaining to the "natural, unconscious, instinctive zone."[25] Freud identified wild horses as substitutes for a dreaded father figure.[26] Jung, on the other hand, wondered if the horse might not be a symbol for the mother, or the "mother within us," that is, intuitive understanding,[27] or related to "various unconscious manifestations of the 'anima' and 'animus' and man's basic instinctive drives."[28] Equine activity echoes throughout the Thorne-Thomsen family photo albums. "Setting out on a ride" was an occasion recorded over and over. The photographer relates that as an adolescent she went without lunch for a year, saving her money to stable a horse. Supplemented by some funds from Missie, she was able to acquire "Bourbon" for one summer. In her pictures, horses are symbols of emotion and suggest feelings from past experiences. They also symbolize, however, elegance and incredible physical, corporeal power. A progression of constructions created in 1976 and 1978 utilizes the horse to suggest direction, journey, and freedom (pls. 5, 6, 13).

While intrigued by symbolism, the artist was also fascinated with contrasts in scale, distance, and movement. She began to introduce into scenes figures that relate to

human experience and serve as catalysts for the expression of her dream imagery, her feelings and thoughts during the process of "uncovering" the past. The miniature characters are mesmerizing and puzzling (at times, an alienation of individuals in space), prompting the viewer to speculate about the technique used. While the means is not always easy to deduce, it is the larger question of meaning that is far more interesting. This line of inquiry leads to the heart of the macrocosm=microcosm equation.

Thorne-Thomsen is able to access a realm beyond the personal largely through her openness to play and the sort of pictorial automatism practiced by the Surrealists. Play involves free impulse, freedom from particular ends, and a stepping out of mundane reality into a temporary sphere of activity with a disposition all its own, a sort of theater. Playfulness itself is a creative state. "Play casts a spell over us," writes the philosopher J. Huizinga, author of the seminal book on the subject, "it is 'enchanting,' 'captivating.' It is invested with the noblest qualities we are capable of perceiving in things: rhythm and harmony."[29] The historical connection between play and art confirms the seriousness of the subject. A true player is intensely and utterly absorbed in the activity at hand. The German philosopher Hans-Georg Gadamer, writing on the hermeneutics of art and literature, noted that Kant characterized the "disinterested, nonpurposive, and nonconceptual quality of delight in the beautiful" as "an affective state of mind in which our faculties of understanding and imagination cooperate with one another in a kind of free play."[30] Even denotations for the elements of play are aesthetic terms, used also to describe the effects of beauty: tension, balance, contrast, variation, etc.[31]

In creating often "beautiful" images, Thorne-Thomsen unconsciously infuses an undeniably psychological charge. The obvious Freudian interpretation of her towers, columns, and blimp as phallic suggests the influence of the work of the proto-Surrealist, metaphysical painter Giorgio de Chirico (Italian, b. Greece 1888–1978), whose representations of lonely

Fig 11. Giorgio de Chirico, *The Nostalgia of the Infinite*, 1911.
Oil on canvas, 53¼ x 25½ inches.
Purchase, The Museum of Modern Art, New York.

city squares, arcades, trains, towers, classical sculpture, and distant figures in silhouette provide a lexicon of symbols that speak to Thorne-Thomsen (see fig. 11). Likewise, her collage aesthetic and device of floating or levitating figures and chairs present close links with the spirit of the work of many of the Surrealists who also admired de Chirico's work.

"To close oneself off from play, at least from the play of imagination as adult discipline bars it, is, one can see, to undermine in oneself the best part of man."[32] As suggested by these words of André Breton (French, 1896–1966), Surrealism was rooted in psychoanalytic (and inevitably artistic) concerns. It was characterized by an interest in individual dreams, myth, and fairy tales, all subjects integral to understanding the work of Ruth Thorne-Thomsen. As a professor, she would begin her classes by reading a folk or fairy tale to her students in order to assist them in moving into another dimension, changing perspective, becoming more receptive. In her childhood, Missie read her Greek myths; her paternal grandmother, "Goomie," read her Norwegian folktales; and her parents filled her with stories of Tom Thumb.[33] Everyone in her family believed in this character, so when on vacation her younger brother Roger shouted to their father to stop the car because he spotted Tom Thumb in the landscape, they all rushed out to find the small person. While most certainly a full-scale human figure miniaturized by standing atop a distant hill, this Tom Thumb represents a childhood memory that effected aesthetic pleasure in a variety of tales imparting a flavor of magic, wizardry, enchantment, and symbolic metaphor, religious and local legends, short stories, fables, and poetry. It also injects new meaning into those photographs filled with lilliputian characters in the landscapes. They symbolize the "traveler" — either the photographer or the viewer; their small scale suggesting their insignificance in relation to nature and their large scale connoting dominance.

Arguably, the seminal work of *Expeditions* is *Head with Ladders, Illinois*, 1979 (pl. 17). The photograph acts as a window, a voyeur's picture inside the thick black band of the window frame, in which the viewer watches a stage play about a magic land, a garden around which a universe can expand. One can surmise a variety of interpretations: the figures inspect the remains of a lost generation, conduct a surgical procedure on an unearthly being, or contemplate the climb toward knowledge, with the ladders serving as access to a higher plane of wisdom. Like all the others, this extremely accessible work naturally lends itself to viewers' imposed narratives, but it uniquely combines the qualities of the epic and the lyric and can be linked directly to a literary heritage (although this was not known to the

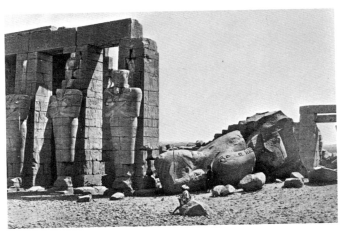

Fig. 12. Francis Frith, *Osiride Pillars and Great Fallen Colossus*, 1858.
Albumen print, 6¼ x 9 inches.
The Art Institute of Chicago Collection.

photographer before its creation). Informed again by the influence of Francis Frith, *Head with Ladders*, together with Frith's *Osiride Pillars and Great Fallen Colossus* (fig. 12) and an earlier Thorne-Thomsen, *Ozymandias, Illinois*, 1978 (pl. 14), coincidentally mark an alliance with the work of Percy Bysshe Shelley (British, 1792–1822), whose poem *Ozymandias* recounts the myth:

> I met a traveller from an antique land
> Who said: Two vast and trunkless legs of stone
> Stand in the desert....Near them, on the sand,
> Half sunk, a shattered visage lies, whose frown,
> And wrinkled lip, and sneer of cold command,
> Tell that its sculptor well those passions read
> Which yet survive, stamped on these lifeless things,
> The hand that mocked them, and the heart that fed:
> And on the pedestal these words appear:
> "My name is Ozymandias, king of kings.
> Look on my works, ye Mighty, and despair!"
> Nothing beside remains. Round the decay
> Of that colossal wreck, boundless and bare
> The lone and level sands stretch far away.[34]

An account by the Greco-Roman historian Diodorus Siculus, writing in the first century B.C., reputedly inspired Shelley to write about Ozymandias and the "vast and trunkless legs of stone." Siculus believed that the Ramasseum was the burial place of the legendary Egyptian potentate Ozymandias: "...it seems altogether likely that the name was a Greek corruption of the name Wesermaatra-Ramses, prenomen and nomen of Ramses II."[35] Desmond King-Hele, author of *Shelley, The Man and the Poet*, confirms the Greek names for the pharaoh and attributes a key line in the poem — "My name is Ozymandias, king of kings" — as paraphrase for an inscription on an Egyptian temple — "I am Ozymandias, king of kings" — recorded by Diodorus Siculus.[36] The colossal figures that inspired the story can still be seen at Thebes. Although actually a Celtic head dissected from a book on prehistoric and Celtic sites of Britain, the head in Thorne-Thomsen's *Head with Ladders* might as well have been that of the fallen colossus Ramses.

While she was teaching at Columbia College Chicago (1974–83), Thorne-Thomsen had received a National Endowment for the Humanities grant targeted to educators at small schools that lack resources for the advanced training that is often pivotal for young professors. Thorne-Thomsen proposed to trace the footsteps of the photographer Eugène Atget (French, 1857–1927). In 1979 she traveled to Paris with a group of art historians led by Theodore Reff, the renowned professor at Columbia University. In the streets and in the private and public gardens of Paris — the Tuileries, the Luxembourg, the Palais Royal — as well as the gardens at Versailles, St.-Cloud, Sceaux, and Arcueil, Thorne-Thomsen photographed in a straightforward, documentary fashion (see figs. 13, 14). Enchanted by his work and that of Charles Marville (French, c. 1816–1879), which she also found among the stacks, she steeped herself in the treasures of the Cabinet des Estampes of the Bibliothèque Nationale, the Caisse Nationale des Monuments Historiques, and the Musée Carnavalet, among the other French photographic repositories. When she returned to Chicago, new images came pouring out. Four of the most frequently reproduced and critically addressed photographs in *Expeditions* — *Head with Ladders, Illinois, Tower, Illinois, Head with Plane, Illinois,* and *Sphinx, Illinois* (pls. 17–20) — followed that most fruitful trip to France. In addition, the seeds were planted for a later series of work — *Messengers*, created in 1989–90 — inspired in part by Atget's photographs in the gardens.[37]

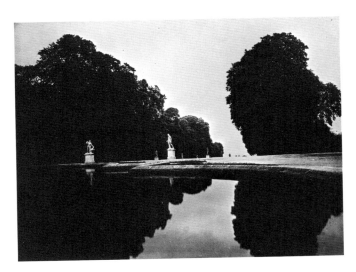

Fig. 13. Eugène Atget, *St. Cloud, 1915—19.*
Albumen print, 7 x 9⅜inches.
Abbott-Levy Collection, Partial Gift of
Shirley C. Burden,
The Museum of Modern Art, New York.

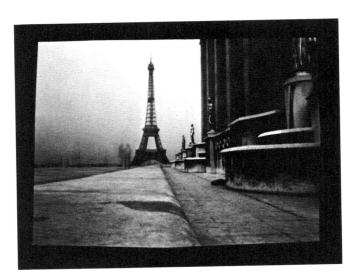

Fig. 14. Ruth Thorne-Thomsen, *Eiffel Tower,
Paris,* 1978.
Toned silver gelatin print, 4 x 5 inches.
Collection of Ruth Thorne-Thomsen.

The late phase of the *Expeditions* series is marked by the use of the photograph itself as an object or prop. Curling her own prints, Thorne-Thomsen created works such as *Paper Palms, California,* 1981, and *Cylinders, California,* 1982 (pls. 24, 26). The "shaping" of her photographs was influenced by Herbert Bayer's photomontage *Metamorphose,* 1936,[38] a geometric interlacing of cylinders and cubes tumbling out of the picture plane (fig. 15). Thorne-Thomsen continued her formal groupings of columns, cones, cylinders, pillars, pyramids, and trees, repeating the forms within the rectangles. Despite her straightforward methodology, however, chance intervened. While photographing on the beach, her camera was twice knocked down by advancing waves. In her darkroom, she discovered that some of her pictures had been magically transformed by streaks of light. The photograph *Geometric Lady, California,* 1982 (pl. 29) likewise is a picture blessed by chance. When the pro-

file of the head of Hera, the greatest of all the Olympian goddesses (in the artist's own heart, the head of Missie), set in a sandy landscape, blew over, the photographer was happily surprised by its richly patterned verso. She picked it up, reversed it, and made the photograph. Unbeknownst to her at the time, with the flip of the matrix, *Geometric Lady* became the precursor for the series *Views from the Shoreline*, in which profiles are not endowed with the characteristic features of the individual, but are assemblages of memories, visions, thoughts, and desires. Despite these fortuitous accidents, her work was gradually

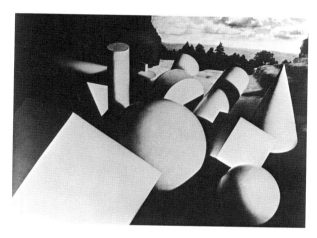

Fig. 15. Herbert Bayer, *Metamorphose*,
(Metamorphosis), 1936.
Silver gelatin print, 10 x 13½ inches.
Bayer Archive Collection, Denver Art Museum.

losing its playful nature; these later *Expeditions* pictures, according to the photographer, were based more on formal qualities than inspiration.

The years 1982 and 1983 were transitional for Thorne-Thomsen. Ready to move into a new domain with greater or different responsibilities, she took a leave of absence from Columbia College Chicago when she was awarded a Visual Artist Fellowship from the National Endowment for the Arts. While on leave, she applied for a position as head of the photography program at the University of Colorado, Denver. One of her recommendations was written by Ray Metzker, who had been teaching at Columbia College from 1980 until 1982. Shortly thereafter, Thorne-Thomsen and Metzker decided to go together to Greece.

Paros, a Cycladic island off the coasts of Greece and Turkey, was unfamiliar territory. Thorne-Thomsen was fascinated by the Aegean and mesmerized by the ships passing in the distance. She and Metzker had flown into Athens in the spring of 1983. On the day that they embarked for Paros from Piraeus, the normally brilliant skies were gray — perhaps a metaphor for the coming change in her work and her life.

> The wanderer later chose this spot of rest
> Where marble clouds support the sea
> And where was finally borne a chosen hero.
> By that time summer and smoke were past.
> Dolphins still played, arching the horizons,
> But only to build memories of spiritual gates.[39]
>
> Hart Crane

The pair took up residence in a house on a hill overlooking the harbor. From the house, the home of the photographer Laurence Bach (American, b. 1947), one could see the ferryboats constantly moving back and forth between ports. To Ruth Thorne-Thomsen they were expressive of a poetic timelessness. She made numerous pictures of these fleeting white ships, thinking that back in the United States she would enlarge her negatives in order to get the misty effect she could see and feel. Although the photographic project with the vessels did not work out as planned, the ships would continue to appear sporadically in her series *Door* and *Views from the Shoreline* until they were recast as major parts in the series *Songs of the Sea*, created in 1991. Ideas for photographs continually evolved. The dreamy, ethereal Aegean would be translated in her next series, *Door*.

Door

Thorne-Thomsen learned that she had been offered the position at the University of Colorado from a letter addressed:

> Ruth Thorne-Thomsen
> Marcos' Bookstore
> Paros, Cyclades
> Greece

"I was thrilled to get word, but I couldn't help thinking how bizarre was the circumstance of picking up such an 'official letter' at the store where we shopped and collected our mail." When she returned to Chicago in the summer of 1983, she visited her family's home in Door County, Wisconsin. The house faces Death's Door, a passageway between the islands in Lake Michigan through which freighters carrying iron ore for refining pass on their way from Green Bay, Wisconsin, to Gary, Indiana. The resulting images — diffused, foggy — had as much to do with her state of mind (for she turned forty while in Greece) as the notion of passage and death — the namesakes for the locale — because Port des Morts Strait, between the tip of the Door County peninsula and Washington Island, is a treacherous crossing.

Thorne-Thomsen found herself groping with unknowns — aspects of birth, death, and rebirth. Atmosphere envelops and softens the contours of every object and figure in foreground, middle ground, and distance, transforming them into segments of dreams, tempestuous images within the depths of the unconscious. Something was trying to come to the surface of the photographer's consciousness, and she wanted to be receptive to the inner voice.

> ...through dreams a door is opened to mythology, since myths are of the
> nature of dream, and that, as dreams arise from an inward world un-
> known to waking consciousness, so do myths: so, indeed does life.[40]

Joseph Campbell

From the beginning, Thorne-Thomsen had recognized the dreamlike quality of her photographs and realized that she was working with symbolic content, but she did not know all that it could mean for her audience and herself. To increase her understanding of symbols, she continued to read books on Greek mythology, dreams, and psychology, and became more intrigued with the work of the Swiss analyst Carl Gustav Jung. For Jung, vision,

dream, and myth are fruits of the inner life continuously flowing from the unconscious. In 1982 Thorne-Thomsen sought out a Jungian analyst in Chicago to help her go deeper into the symbolism of her work. Moving beyond any kind of personal pathology, Caroline Stevens assists the artist with dream interpretation and coming to know her "Self."

Dreams, those important, integral, and personal expressions of the individual unconscious, are referenced throughout Jung's treatise *Man and His Symbols*, his last work before his death in 1961. His contributions were heralded by the literary and scientific communities, who praised his service to psychology as a science, and to a general understanding of man in society with his insistence that "imaginative life must be taken seriously in its own right, as the most distinctive characteristic of human being."[41] According to Jung, dreams are "direct, personal, and meaningful communications to the dreamer,"[42] which contain symbols that are common to all mankind. In dream interpretation, personal associations are separated from the dream elements that are not individual: "archaic remnanta" for Freud, "archetypes" or "primordial images" for Jung.[43] Further, archetypes are the content of the *collective unconscious*. Jung writes:

> The collective unconscious is a part of the psyche which can be negatively distinguished from a personal unconscious by the fact that it does not, like the latter, owe its existence to personal experience and consequently is not a personal acquisition. While the personal unconscious is made up essentially of contents which have at one time been conscious but which have disappeared from consciousness through having been forgotten or repressed, the contents of the collective unconscious have never been in consciousness, and therefore have never been individually acquired, but owe their existence exclusively to heredity. Where the personal unconscious consists for the most part of *complexes*, the content of the collective unconscious is made up essentially of *archetypes*. The concept of the archetype, which is an indispensable correlate of the idea of the collective unconscious, indicates the existence of definite forms in the psyche which seem to be present always and everywhere. Mythological research calls them "motifs"; in the psychology of primitives, they correspond to Lévy-Bruhl's concept of "représentations collectives," and in the field of comparative religion they have been defined by Hubert and Mauss as "categories of the imagination."[44]

Jung contends that because there are innumerable things beyond the range of human understanding, we use symbolic terms to represent concepts we cannot define or fully comprehend.[45] These archetypes produce certain psychic forms that are involuntary, spontaneous products of the unconscious psyche. Thorne-Thomsen comments, "Spontaneity is one way I can get to tell the truth. When I am spontaneous, I know it is really coming from my 'Self,' and it is not the ego trying to do the right thing, to look good. It involves trust in oneself." She found the Wisconsin shoreline fertile ground for her imagination. Water, one of the four primary forms of matter, is a profound symbol that has represented mother, Mother Earth, birth, life, unfathomable, impersonal wisdom, death and interment, life and resurrection, and the unconscious. The most transitional of the elements, water is, by analogy, a mediator between life and death. The *Door* series, with its literal archways and suggested avenues, represents the entrance or opening to the unconscious realm.

Thorne-Thomsen brought to Door County numerous props to keep close at hand as she responded to the landscape. Playing with the symbolic characterization of water and rock of Lake Michigan (which would later translate in her series *Prima Materia*), she felt

compelled to add ladders, pillars, photographs of buildings, and arcs, as she began to explore literal and spiritual passageways into unknown territory. The photograph *2-Face, California*, 1982 (pl. 35) hints at two potential paths, for example, the "Méséglise and Guermantes ways" of Marcel Proust. For the photographer and viewers, the stone in the photograph can embody two visions of life possibilities, the myth of Gemini, good and evil, anima/animus, yin and yang. It also suggests the Roman deity Janus, a symbol of wholeness, of the desire to master all things. The faces of Janus turn toward the past and the future, denoting both awareness of history and foreknowledge.[46] Here the photographer took another step toward self-discovery. Her desire not to see things *sharply* (as the medium enables) is a point of departure for something else. The forms themselves are not the important elements; rather, her archetypal imagery filled with references to classical antiquity connotes the past as meaningful and important, a source of knowledge for the present.

In submerging heads on the rocks, Thorne-Thomsen found metaphors for her life. "I had this sensation that because I was feeling even more alive, death could be very close." She was energized by her trip to Greece and the prospect of a new job in a new city; however, she was starting a new life. While taken with Ray Metzker, she had no idea what would develop in that regard. Completing an entire body of work in three weeks,[47] she headed off to Colorado.

Ending "Expeditions"; Beginning "Prima Materia"

When she arrived in Denver in 1983, Thorne-Thomsen worked hard at developing a photography program with a first-year emphasis essentially modeled after the foundation year in photography at Columbia College Chicago: a program of study separated equally into creative and technical aspects, recognizing that the aesthetics of photography emerge from the materials of the medium. But she also traveled around Colorado and nearby Utah, Arizona, and New Mexico doing her own work. She was moved by the scale of this part of the country. She made a point of visiting Monument Valley but also came upon Arches. At ease in the vastness of the West, she rented a bungalow for a month in 1987 in Castle Valley, Utah, the site of the home she and Metzker later purchased in 1989.

There, in the valleys, gorges, and gullies of the American West, *Expeditions* came to an end. The photographer was transplanted into deep space punctuated by ancient rock, the expanse she had been trying to devise all along in her photographs. The Western landscape was luxurious and amazing, a kind of stretch not found in all of Europe. But something was missing for the photographer: it is interesting that as an artist from a nation without classical history or fabled ruins, she chose to inject ancient relics into the American landscape. The works *Columns at Monument Valley, Arizona, Stoneface, Utah, Fallen Face, Arizona,* and *Ray at Monument Valley, Arizona* (pls. 30–33), all created in 1984 with an eccentric flavor of classical antiquity, influenced by her travel to Greece the previous year, would be the final works in the series. They also mark the last time Thorne-Thomsen used her pinhole camera. In the fall of 1985, she took a leave of absence from the University of Colorado to travel with Metzker to Italy and to pursue changes in her work.[48]

Prima Materia was started in Italy with a Graflex Super D that the artist fitted with a lens and an aperture built to achieve infinite depth of field. This decision is notable, because for the first time in approximately ten years, Thorne-Thomsen was able to see

what the camera observed. She peered through the pinhole aperture and was amazed by the flickering shadows. Although she had become adept at recognizing the sweep of the camera obscura's field of vision and the effects it could generate, even reveling in its surprises, without a viewfinder she was not able directly to compose her exposures. Now she could frame her landscapes with a normal lens, insert the pinhole aperture, and patiently wait for her eyes to adjust. Although she could scarcely see the landscape, figures, and forms that she had lined up before the camera, she took her time to reflect on their positioning and scale before shooting. The change in camera, and the use of sheet film, excited and challenged her.

For four months Thorne-Thomsen lived in Castagneto di Carducci, a hillside town in Tuscany surrounded by olive groves and stands of Italian stone pines. Impressed by the appearance of the gnarled olive trunks, the startling life span of those trees and the "umbrella" pines — which can live a remarkable 250 years — the bridges and monasteries, vineyards and rocks, which have endured so many centuries on earth, she thought about creation: matter moving, forming, becoming something, *prima materia*.[49]

Breaking from the literal, she began to make up forms by cutting shapes out of the patterned planes in her photographs of the Italian pebble beaches. She injected the profiles, pyramids, and figures back into the environment. Stones, pebbles, and chunks of unhewn rock interested her not only for their permanent nature, but also for their religious and astronomical significance, and as enigmatic symbols. She was intrigued by mineral matter serving as metaphor for bones of the earth — our matter, our mater, our mother. Interested later by what she read of the controversial Gaia contention that the earth as a whole is alive,[50] she now read even more clearly into the pictures of this series with a macro/microcosmic eye: glimpsing our bodies as a world. *Earthling, New Mexico*, 1987 (pl. 56) perhaps best represents the concept: an indissoluble unity of man and nature. The desolate terrain of New Mexico provides an excellent backdrop for the figure to sink into or emerge from the earth. Similarly, the American West has served as the site for many Earth Art constructions that assert the harmony of the physical world. Most notably, Robert Smithson (American, 1938–1973) manipulated vast quantities of earth and rock to produce *Spiral Jetty*, 1970 (fig. 16), a coil of earth and stone built out from a shore of the Great Salt Lake in

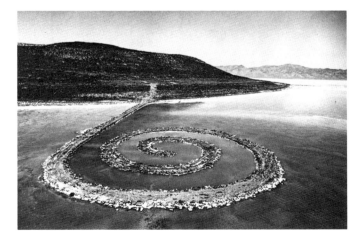

Fig. 16. Robert Smithson, *Spiral Jetty*, April 1970.
Black rocks, salt crystal, earth, red water, algae,
L. 1,500 feet, W. 15 feet.
Great Salt Lake, Utah. Estate of Robert Smithson,
Courtesy John Weber Gallery, New York.
Photograph by Gianfranco Gorgoni.

Utah. Moving and reshaping black rock, salt crystal, earth, red water, and algae, Smithson emphasized both the work and the contextual setting in reciprocal relation, sharing the same reality. Ruth Thorne-Thomsen sought similar reciprocity in her work between man and nature.

A difficult series to resolve, *Prima Materia* continues to be a source of inspiration for the photographer. It enables her to meditate on Nature itself, on the granular makeup of the earth, on the veins of rock and water that run beneath. Although the series remains unfinished, the creation of one image, *Two Faces Are a Vase, Italy*, 1985 (pl. 52), with its familiar optical illusion, propelled her into the next series. Interestingly, it is two faces, two views, that again mark the artist's path.

Views from the Shoreline

From the geographical point of view, it was fated that a first conscious manifestation of great metaphysical painting should be born in Italy. It could not have happened in France. The facile virtuosity and well-cultivated artistic taste, mixed with such a dose of *"esprit"* (not only in the exaggerated punning sense) as powders 99 percent of the inhabitants of Paris, would suffocate and impede a prophetic spirit. Our terrain, on the other hand, is more propitious for the birth and development of such animals. Our inveterate *gaucherie* and the effort we have continually to make to accustom ourselves to a concept of spiritual lightness, have determined the weight of our chronic sadness.[51]

Giorgio de Chirico

Ruth Thorne-Thomsen was stirred by the Italian countryside and art and architecture. The vistas, the Sienese frescoes, the allegorical paintings of the Renaissance, the piazzas and arcades of the Italian cities, as portrayed in the work of Giorgio de Chirico, among other artists, were fodder for her imagination. The ancient ruins and landscape also connected her even more closely to the ground. Italian culture — in fact, that of all countries with ancient histories — favors the integration of man and soil. In contemporary North American culture, however, the head reigns supreme, controlling nature through technology. Upon her return to Colorado, Thorne-Thomsen was energized with a quest to reconcile this cultural split between mind and body, and to bring both together in harmony with the earth, a process she had started in *Prima Materia*.

Views from the Shoreline was influenced by the early Florentine portraits that present sitters in their least psychologically revealing, yet distinctive and emblematic poses — in profile and gazing away from the onlooker. Particularly important was the work of Piero della Francesca, which Thorne-Thomsen had appreciated since her childhood. Indeed, when the exhibition "The Great Age of Frescoes: Giotto to Pontormo," including works by Giotto di Bondone (c. 1266–1337), Fra Angelico (c. 1387–1455), Piero della Francesca (c. 1420–1492), Jacopo Pontormo (1494–1556), and other early Renaissance artists was presented at The Metropolitan Museum of Art in New York in 1968, she drove directly from Carbondale, Illinois, where she was studying painting at the university, to see the show. She admired in particular the beauty and formal properties of Piero's heraldic *Battista Sforza* and *Federigo da Montefeltro* (figs. 17, 18), but especially the deep, magical space in the landscape behind the figures.

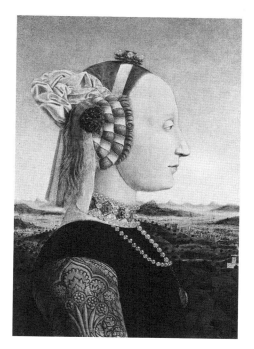

Fig. 17. Piero della Francesca,
Battista Sforza, 1472–73.
Oil on panel, 18¾ x 13¼ inches.
Galleria degli Uffizi, Florence.

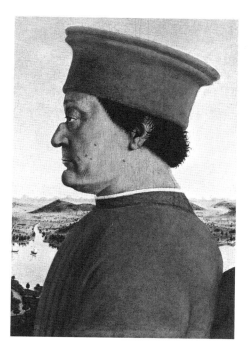

Fig. 18. Piero della Francesca,
Federigo da Montefeltro, 1472–73.
Oil on panel, 18¹¹⁄₁₆ x 13¼ inches.
Galleria degli Uffizi, Florence.

Logically, but erroneously, critics of Thorne-Thomsen's work have compared *Views from the Shoreline* with the paintings of the Mannerist Giuseppe Arcimboldo (Italian, 1527–1593) (see fig. 19), whose bizarre human profiles made of fruit, flowers, and other still-life objects do resemble Thorne-Thomsen's profiles, but do not incorporate her interest in landscape and the compression of space evident in the background of Renaissance paint-

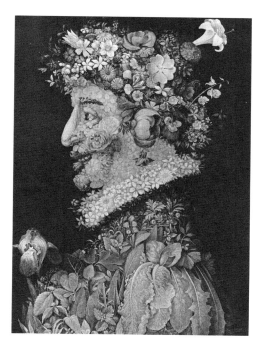

Fig. 19. Giuseppe Archimboldo, *Spring*, 1563.
Oil on panel, 26¼ x 19¹³⁄₁₆ inches.
Real Academia de Bellas Artes de
San Fernando, Madrid.

ings. A closer comparison is the 1938 painting by Man Ray (American, Emmanuel Radenski, 1890–1976) titled *Imaginary Portrait of D.A.F. de Sade* (fig. 20), with its landscape of the subconscious, the internal regions of de Sade's mind—"symbol of artistic freedom." The controversial French novelist witnesses the burning of the Bastille, represented outside his silhouette, "symbolizing the destruction of all that is responsible for the imprisonment of the spirit." In *Perpetual Motif: The Art of Man Ray*, Stephen C. Foster further remarks that this painting is probably Man Ray's "most frankly ideological and symbolic.... It is the unique reflection of near perfect parity between himself and another individual."[52] In a similar fashion, Thorne-Thomsen psychologically pairs herself with the profiles of feminine characters and creates a series of works visually uniting the female head and the earth. The energy of the human profile—a hard line of demarcation—against the stark background is a frontier between the actual world and abstract space. The profile sets up dichotomous parts of the picture in which "the image inside the profile is made private and timeless, a metaphorical representation of a person's interior life; the outside...public and historical."[53]

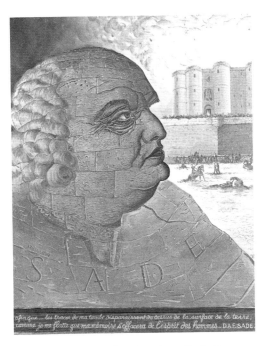

Fig. 20. Man Ray, *Imaginary Portrait of D.A.F de Sade*, 1938.
Oil on canvas with painted wood panel,
24¼ x 18⅜ inches.
The Menil Collection, Houston.
Photograph by Janet Woodard.

Thorne-Thomsen expanded upon the landscapes of Piero della Francesca with the use of sky-background, which in the later fifteenth century was a harbinger of the portraits of the day with the sitter commonly placed on a parapet. Rather than present a vista of the rulers' land, however, Thorne-Thomsen poetically suggested either placid or rough terrain—dichotomous possibilities for mankind's environment—and less fruitful topography than the fertile plains pictured in Piero's portraits of Federigo and Battista. Herein she carefully epitomized the contradiction of the European and North American relationship between man and nature. The large size of the profiles and their closeness to the picture plane emphasize heady control, while the interiors of the vignettes propose more benevolent choices. The

inner vistas with roadways, bridges, ladders, rivers, hilltowns, architectural pediments, and cascading, structural, and aged elements of nature — all very archaeological in their context — also connote a "remembrance of things past" (the word *past* also intimating archaeology), to borrow from Proust.

The works in *Views from the Shoreline*, a metaphor for the ocean of the unconscious, came very quickly for the photographer. She worked intently in 1986 and 1987 with her Graflex and negative film, repeating profiles cut from her collection of imagery, for example, a profile of her friend Sharon, echoing first in *Prima Materia's Two Faces Are a Vase*, 1985, then in 1986 in *White Ship, Utah* and *Waterfall, Colorado* (pls. 65, 67); a silhouette of

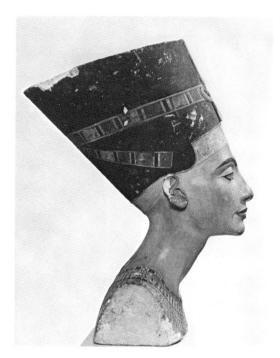

Fig. 21. Egyptian, Tel el-Amarna, *Queen Nefertiti*,
c. 1360 B.C.
Limestone, H. approx. 20 inches.
Ägyptisches Museum, Staatliche Museem
Preussischer Kulturbesitz, Berlin.
Photograph by Jürgen Liepe.

the famous painted limestone bust of Nefertiti (fig. 21) in 1986 in *Homo-Sum (Venice), Colorado* and *Screwhead, Colorado* (pls. 59, 60); and the contour of the head of Hera also in 1986 in *Harlequin Head, Colorado, Turrita Mater, Colorado*, and *Thunderhead, Colorado* (pls. 57, 62, 63). Although she used only a few matrices, the numerous possibilities of mutation blur the duplication.

Some feminists read into *Views* a satire of the "woman and nature" cliché, because without exception, even in the cases of representing male personas, the cutout matrices are of heads of women. Thorne-Thomsen neither accepts nor rejects this interpretation, but rather turns it to her advantage. Layering her metaphors, she has treaded perilous terrain. Using three of the fundamental constituents of the universe in ancient and medieval cosmologies — earth, air, and water — she has endowed her landscapes with the prominence and poetic force of a protagonist binding mind, earth, and body — in this case that of a woman, but representative of mankind. She also incorporated here

myths of ancient cultures to which the titles of the pictures allude: *Homo-Sum*, Latin for "I am a human being"; *Nepenthe*, a potion used by the ancients to induce forgetfulness of pain or sorrow; *Niobe*, in Greek mythology, a daughter of Tantalus and the wife of Amphion who, while weeping for her slain children, is turned to stone although her tears continue to flow.[54] Further, Thorne-Thomsen integrated the work of other artists, such as the Italians Sandro Botticelli (1444–1510) and Leonardo da Vinci (1452–1519), the artist who gave substance to the Renaissance concept of *l'uomo universale* — difficult choices for a *woman* of the 1990s (women artists were not mentioned until the late seventeenth or early eighteenth century), but ideal selections for an artist uncovering the past. Such rich layers of metaphor load each photograph with the heavy burden of history.

Celia Rabinovitch, a colleague at the University of Colorado, Denver, mentioned to Thorne-Thomsen Leonardo da Vinci's writings on the spiral as a basic form in nature — an idea that had direct bearing in 1986 on the creation of *Screwhead, Colorado* and *Leda, Col-*

Fig. 22. Leonardo da Vinci, *Leda*, 1504–08.
Pen and ink over black chalk on white paper,
7¹³⁄₁₆ x 6⅜ inches.
Royal Library, Windsor.

orado (pls. 60, 61).[55] Leonardo's own *Leda* (fig. 22), Baroque in effect, remains an extreme example of the artist's love of twisting forms, consistent with his theory of the rhythmic movement of nature into a spiral: water swirling, smoke climbing, the striated grooves of a conch, a leaf unfolding. The forms reemphasized for Thorne-Thomsen the macrocosm=microcosm equation so pervasively integral to her philosophy. In tandem with their metaphorical strata, the photographs present an amalgamation of the dilemma between the head and the heart, reason versus feeling. In the end, the series has enabled the artist to come to a greater understanding of the relationship that exists between the spiritual woman and her physical matrix.

The years 1987–89 were a time of experimenting and exploration. Thorne-Thomsen made images from the series *Views from the Shoreline* in three sizes: roughly 4-by-5 inches, 30-by-40 inches, and 4-by-5 feet. Trying to develop another illusion of deep space in the summer of 1988, she created studio sets with photographs as backdrops. These latter

experiments never really worked. In addition, the long-distance relationship that she had maintained for five years with Ray Metzker was experiencing some strain; it was difficult to remain separated by so many miles. In the summer of 1988, they split up.

Thorne-Thomsen wanted more time to spend with her photography. She resigned from the University of Colorado and gave herself two years to see if she could manage to be an independent artist; if not, she would return to teaching. Coincidentally in 1989, she and Metzker received Visual Artist Fellowships from the National Endowment for the Arts. The two had indicated on their respective applications interest in completing residencies in France (the application offered the option of France or Japan). On the plane ride out, they decided to give their relationship another try. Thorne-Thomsen was now freed from teaching responsibilities; she was definitely leaving Colorado and was thinking about moving to the Southwest. When she returned from France, however, she went to California to visit her parents, took care of loose ends in Colorado, and went to her new home — Philadelphia, where Metzker lived — to begin a penetrating series founded on the Côte d'Azur.

Messengers

La Napoule Art Foundation was established in 1951 to promote the exchange of American and European art and culture. Its programs take place at the Château de La Napoule, the former home of the expatriate American artist Henry Clews (1876–1937). The Château, the Villa Marguerite, and the surrounding gardens and courtyards offer a private setting for artists to live and work. On the shores of the Mediterranean, five miles from Cannes, the foundation is located in the heart of a region that has inspired generations of painters, sculptors, writers, composers, and performing artists. In addition to its residency programs, La Napoule Art Foundation annually hosts conferences, seminars, and workshops.

Surrounded by paradise, the balcony of her studio overhanging the Mediterranean Sea, Thorne-Thomsen nevertheless was not at peace. During the three months that she experimented with a 35mm camera, she accidentally blurred one of the classical heads that she often used as a prop and decided to pursue the effect. She thought of the statues in the Boboli Gardens, so she rented a car and drove to the Pitti Palace in Florence. When she completed her residency at La Napoule, she also drove to Paris and photographed at Versailles, the site of her initial study in 1979 of French gardens after Atget (see fig. 23).

> I remember one vivid winter's day at Versailles. Silence and calm reigned supreme. Everything gazed at me with mysterious, questioning eyes. And then I realized that every corner of the palace, every column, every window possessed a spirit, an impenetrable soul. I looked around at the marble heroes, motionless in the lucid air, beneath the frozen rays of that winter sun which pours down on us *without love*, like perfect song. A bird was warbling in a window cage. At that moment I grew aware of the mystery which urges men to create certain strange forms. And the creation appeared more extraordinary than the creators. Perhaps the most amazing sensation passed on to us by prehistoric man is that of presentiment. It will always continue. We might consider it as an eternal proof of the irrationality of the universe. Original man must have wandered through a world full of uncanny signs. He must have trembled at each step.[56]

> Giorgio de Chirico

Fig. 23. Eugène Atget, *Statue de coureuse
aux Tuileries*, 1906—07.
Albumen print, 8⁹⁄₁₆ x 7 inches.
Musée Carnavalet, Paris.

The statuary in the grottoes, rocaille, theaters, islands, pools, and fountains in the gardens at Versailles as well as the Pitti Palace provided the necessary component for the "message carriers"[57] of Thorne-Thomsen's unconscious. It is interesting that they would be located in the gardens, for it was there that all the resources of mythology and allegory were called upon to symbolize the universe and celebrate the excellence of the monarchs for whom they were constructed. While French and Italian gardens are laid out along early Renaissance architectural principles, their history stretches back to classical times. Peopled with statuary that is tantalizingly human, the gardens are a kind of theater wherein a continuous drama unfolds.

Thorne-Thomsen began *Messengers* with straightforward 35mm records of the garden statuary. While it is possible to reference the allegorical, historical, and mythological characters, and rustic genre subjects (often paired ironically in the gardens at Versailles and the Pitti Palace), for example, Helen in *Messenger #4, France* (pl. 72); Neptune in *Messenger #10, France* (pl. 80); Dionysus in *Messenger #12, Italy* (pl. 75); Judith, who if featured in full frame would hold the head of Holofernes, in *Messenger #13, Italy* and *#14, Italy* (pl. 76); a young man from a typical genre scene in *Messenger #15, Italy* and *#16, Italy* (pl. 74), the names of the prominent and common figures and the garden deities they represent are not important. Ruth Thorne-Thomsen intentionally obliterates reference to a certain historical period in favor of creating timeless symbols, the voices of a collective unconscious.

Returning to the United States and ensconced in her Philadelphia third-floor studio on Chestnut Street, Ruth Thorne-Thomsen enlarged her negatives into 11-by-14-inch prints. Responding to music, she panned before them with her camera, recording scores of new negatives. She attempted to generate so much force that an interior power would make her way of seeing stronger and more completely articulated. Through movement, she sought access to an inner source; her vibration and pulsation giving life to the meaning "conscious-

unconscious exchange." Whereas dream symbols are the "essential message carriers from the instinctive to the rational parts of the human mind,"[58] the *Messengers* became transmitters of expression from characters of an inherited past. Her motion set the forces in a timeless drift—forces that act in all humanity, Thorne-Thomsen's inner voices personified.

The resulting images, blown up to 30-by-40-inch murals, plunge viewers into drama. Whereas they had to peer through or squeeze into the windows of the intimate landscapes of the earlier works, they were now confronted by the forceful presence of larger-than-life ancestors exuding suppressed desires and wishes. As a relatively new series so different in its overt passion from her previous works, *Messengers* arouses mixed feelings. Some collectors of these works have found *Messenger #12, Italy* and *#16, Italy* symbolic of the pain and anguish of the Holocaust and the AIDS crisis; others ascribe to them attributes of the planets, with *Messenger #1, Pennsylvania* (pl. 77) as Venus and *#12, Italy* the moon, characteristics of harmony and truth with *Messenger #20, France* (pl. 73) as art or beauty and *#17, Italy* (pl. 79) philosophy or wisdom, or fundamental constituents of the universe as described in ancient and medieval cosmologies—*Messenger #12, Italy* as earth, *#2, France* (pl. 78) as air or wind, *#4, France* as fire, and *#14, Italy* as water. The commentary is interesting in light of the symbols standardly attributed to the statuary: abundance, overindulgence, wealth, triumph, terror, melancholy, and longing. None of these latter qualities is typically used to describe the *Messengers*. Rather, larger philosophical, humanitarian, and environmental properties and concerns are equated, perhaps reflective of the important messages these carriers, weathered by time, sustain from a collective past. In her striving for anonymity and timelessness, Thorne-Thomsen is most successful here.

At first glance, the large and aggressive *Messengers* represent a radical departure from the miniature and engaging works typically associated with Thorne-Thomsen. However, a more keen examination reveals the artist examining her same basic theme through a different grammar of photography—the closeup. Uncovering the past, she homes in on her subjects, this time with intense scrutiny. Gradually, she closes in on the core of her work, shooting first from a distance in *Expeditions*, *Door*, and *Prima Materia*, then at midrange in *Views from the Shoreline*, and upfront in *Messengers*. For this last series, Ruth Thorne-Thomsen changed her equipment (pinhole camera to 35mm and paper negatives to roll film), her method of working (in the studio versus on location), and her perspective (close-in versus distant), and made art out of vital interior experience. Never had she worked so hard and with so much doubt on a body of work. Even today she is frightened by its manifestations of a different power within her as an artist and an individual, one that is not literal but emotional.

Songs of the Sea

A sea-port is a pleasant place for a soul worn out with life's struggles. The wide expanse of sky, the mobile clouds, the ever-changing colors of the sea, the flashing beams of the lighthouse form a prism marvelously designed to gladden, without ever tiring the eye.[59]

Charles Baudelaire

Since 1976 Ruth Thorne-Thomsen has had many occasions to reflect on the luminous moods of water—the Mediterranean, the Atlantic and Pacific oceans, the lakes of the Midwest. Water animates the gardens she has explored; in fact, it invests them with life and spirit, movement and sound. At Versailles, water lends itself to different kinds of effects: as mirrors reflecting the skies, as maritime theater wherein fleets of festival boats can float, as manmade rainstorms, as glorious sprays of adulation and celebration complementing the operas, ballets, masquerades, cavalcades, and firework displays on land. Water is the Boboli Gardens' principal ornament; fountains celebrate the element brought to Florence by Cosimo de' Medici. Contemplating the sensuality of the water in these gardens, her resource images of ships in the Aegean and ore boats in Door County, her love of the vast sea, and the beckoning waves and cloud-filled skies on the beach, Thorne-Thomsen began a series of hybrids with familiar symbols. She returned also to her Graflex camera, lens with pinhole aperture, and paper negatives. Having plunged into the depths of the unconscious and unleashed powerful emotions, the artist wished to return to calmer waters.

Reminiscent of Thorne-Thomsen's earlier works in *Expeditions* and *Door*, the photographs in *Songs of the Sea* have an affinity with the early exploratory photographs, in particular those of water basins in the American West by William Henry Jackson (American, 1843–1942) and Timothy O'Sullivan (American, 1840–1882), especially the latter's *Tufa*

Fig. 24. Gustave Le Gray, *Brig on the Water*,
from *The Vistas Del Mar Album*, 1856.
Albumen print from wet collodion on glass negative,
12¾ x 16 inches.
Hugh Edwards Photography Purchase Fund,
The Art Institute of Chicago.

Domes, Pyramid Lake, 1867; and the seascapes by Gustave Le Gray (French, 1820–1862 [see fig. 24]). One of the most brilliant of the French "painter-photographers" of the 1850s, Le Gray began to photograph ships on the sea along the Normandy coast, at Le Havre and at Sainte-Adresse, but also worked, as art historian Eugenia Parry Janis noted in the first monograph on the artist, along the Mediterranean. Both Le Gray and Thorne-Thomsen share an amazement with the splendors of the Mediterranean and the Middle East, and an "insatiable desire to chart great spaces, to become intimate with the vastness of immensity."[60] The expanse of seas and rivers summons the human spirit. Guggenheim fellow Alev Lytle Croutier notes that "not only did waterways present the possibility of great commerce and

communication...they also became a channel for the pursuit of self-knowledge, a place where people confronted their fears and passions." She writes, "the invention of the boat made possible a fluid mobility through waters that would greatly expand the consciousness of the human race."[61] It is interesting to view Thorne-Thomsen's ships in this context. In the evocative *Duet, Wisconsin*, 1991 (pl. 81) (reflective of Le Gray's *Brig on the Water*, 1856), viewers may recall the Greek homecoming from Troy — the catastrophic return after the destruction of the city — but the picture can represent more broadly the uncertainty of the journey itself and the duplicity of fate. For Ruth Thorne-Thomsen, the ships (as well as the statues) symbolize souls and present the very gesture of human destiny. Animated by familiar characters, *Songs of the Sea* includes watery realms enveloped in a natural silence interrupted only by a spectacle of light. Infused with classicism, the pictures allude to mythological subject matter by means of statuary, silhouetted figures, columns, architectural ornaments, ships, and elements of nature itself. Classical mythology associated water with creation and destruction, fertility and death, beauty and sexuality, passion and power, and mystery. The water in *Songs* metaphorically represents the unconscious; columns and pillars signify solidarity and strength — the tangible world; branches and stones, the earth. Yet again, the artist brings to the forefront her quest to bind mind, body, spirit, and nature.

Songs of the Sea also represents, however, the photographer's return to sportive images that, in this case, may remind one of scenes by Renaissance patrons and artists who exploited the "marvelous" in their festival, theater, and garden designs for the sake of entertaining courtiers and amazing them with their visual effects. Thorne-Thomsen's theatrical illusions are similar to those in the elaborate garden performances created for sixteenth- and seventeenth-century Italian courts. Although not a literal reference, an etching and description after the 1661 equestrian ballet *Il mondo festeggiante*[62] (The Rejoicing World) holds visual impressions that bear resemblance to Thorne-Thomsen's *Altar, Wisconsin*, 1991 (pl. 84): a colossal statue, a group of figures atop the statue, water, and the marvel of dramatic display. The survey of the land by Thorne-Thomsen's two travelers, one of them pointing westward, could symbolically link the work to the Florentine celebration or to the direction of nineteenth-century American explorers; guide the pictured companion and also the viewer to an extraordinary vista; or indicate the wilderness still to conquer. Perhaps more in keeping with the spirit of Thorne-Thomsen, the adventurer points out the photographer's fumble — the folded corner of the paper negative in the contact printer. Quickly we are reminded that this is a photographic marvel created with the mechanics of the medium and the humor of the artist.

In this series of garden seascapes with a mixture of the props and symbols that she used in all of her previous series, Ruth Thorne-Thomsen was able to come back to a state of playfulness, joy, and exuberance. It is therefore interesting that she chose to take *Messengers* with her (in fact, the image featured in *Messenger #15, Italy* and *#16, Italy* is pictured in *Songs' Limbo Man, Wisconsin*, 1992 (pl. 91). Rather than injecting a magnitude of force into the atmosphere, however, the characters now communicate with her and one another in pantomime as in *Trio, Wisconsin* and *September 4th, Wisconsin* (pls. 87, 88). Still others, with psychological references implied by titles, e.g., *Guardian* and *Gate* (pls. 89, 90), remind the viewer of the intensity on the edge of tranquility. Thorne-Thomsen's return to the earth and water is an almost polemical reply to her exploration of deep internal space, the interior depths of the psyche. Her work is coming around on itself, but has not yet come full circle.

The Meaning of Ithaca

Always keep Ithaca fixed in your mind.
To arrive there is your ultimate goal.
But do not hurry the voyage at all.
It is better to let it last for long years;
and even to anchor at the isle when you are old,
rich with all that you have gained on the way,
not expecting that Ithaca will offer you riches.
Ithaca has given you the beautiful voyage.
Without her you would never have taken the road.
But she has nothing more to give you.

And if you find her poor, Ithaca has not defrauded you.
With the great wisdom you have gained, with so much experience,
you must surely have understood by then what Ithacas mean.[63]

C. P. Cavafy

It is not only Greece, France, Italy, and Egypt that attract Ruth Thorne-Thomsen, it is the whole of the Mediterranean—the sea, the terrain, the atmosphere, the light, classical civilization's proclivity for the marvelous, the resplendent, dramatic vitality of the people as expressed in their art, theater, legends, tales, folklore, poetry, and myths—an ancient past. Here, especially, the romantic taste for ruins is easily indulged. Focusing upon the antique, she is able to uncover a past that is in our collective and individual memory, a figurative code made up of iconographic models and types that are recognizable because they are experienced and recorded. Her dreamscapes compose an articulate language. We marvel at the works not just for aesthetic or photographic properties, but because they resonate with our experiences or some instinctive, inherited trends. To Freud, the dream revealed something about not only the individual but all humanity. Jung likewise found the dream to be personal communication to the dreamer influenced by a second psychic system of a collective, universal, and impersonal nature that is identical in all individuals. Ruth Thorne-Thomsen revels in the dream qualities of strangeness, puzzlement, invitation, and wonder. Her pictures, like dreams, captivate us through preexisting forms.

Thorne-Thomsen's poetic constructs mark for the photographer and the viewer *release*, enabling spontaneous interpretations. It is for this reason that the photographer delights in the viewer's creative narratives for the pictures. Each story creates another layer of meaning, because the experiences of the interpreter's life also give form to emotion. Although such layering is dangerous, the danger is the power in these works: things glint suggestively in Thorne-Thomsen's photographs, illuminated by the imagination.

Imagination is a power of the mind, as well as the soul, where inspiration directly exerts its influence. If one were to illustrate the source of the power, it would invariably lead to the head. Since antiquity, the head has served as symbol for the mind and spiritual life, and as a form representing character, personality, power, reason, and creativity. It has also been a major component of myths, legends, tales, and art through the ages: Minerva's shield with the head of Medusa, Roman and contemporary currency, allegorical and ecclesiastical stories of Holofernes and John the Baptist, masks by native peoples worldwide, the colossal heads of the Olmecs of Mexico, portrait jars by the natives of Peru, the *Tower*

of Bayon, sculptural heads, and photographic portraits. More contemporarily, the head also symbolizes the world.

Heads appear in each of the six series by Thorne-Thomsen. While most often they surface without torsos, the reverse does occur — on the one hand, a repercussion of nature on the ancient sculpture that is pictured in her work, on the other, a suggestion of deeper meaning — personal and collective. Certainly dreams (or Thorne-Thomsen's images) are better translated within the context of the person's life; however, a Jungian's arbitrary interpretation might explicate the severed heads as symbolic of a separation between thinking, emotion, and the life of the body. Knowledge comes equally from the head and the heart — "the heart has its reasons that reason doesn't know." Perhaps unconsciously that is precisely why Thorne-Thomsen sets her heads in romantic landscapes — to balance reason and feeling. Her penchant for ruins — universal, archetypal symbols of the temporal nature of life — and a classical approach to subject matter (as well as composition) establish an equilibrium in her work.

On a collective level, the heads in Thorne-Thomsen's work represent archetypes from the unconscious, for example, a god or goddess figure, or in the case of this artist, a feminine motif — an "image-emotion" of the artist coming to terms with being a woman. Strategically placed by the conscious determinant of the photographer or the unconscious urging of an inner voice, the heads are combined with other potent symbols: ladders, planes, ships, water, rocks, trees, the landscape. Interestingly, all of these symbols can connote ascension, descension, emergence, and disappearance. As the artist continues her quest for marvelous images, she goes through the process of individuation, rising, sinking, searching for her center; viewers of her pictures unconsciously relate to this process and to the universal struggle to maintain psychological equilibrium, to make sense of the world and experiences. "The dream carries us back into earlier states of human culture," writes Friedrich Nietzsche, "and affords us a means of understanding it better."[64]

Nonlinear by nature of this artist's quest, Thorne-Thomsen's work is oriented in one symbolic line along which nothing is independent and everything is in some way related. Exploring unknown territory, a world of an ancient past, Ruth Thorne-Thomsen mirrors the impression of history, a circle whose center is everywhere and whose circumference is nowhere. Certainly, if one is seeking enlightenment, it is the path of continual choice that is the ultimate goal — the courage to live one's own truth. This alternative third route, ultimately usurping the twofold path, is the only "way" that time does not destroy. The renewal at each turn along the journey is the most compelling and rewarding. Ruth Thorne-Thomsen relates, "I believe images can transform us by expanding our awareness, opening us up to a larger reality. If only for a moment, we can sense a wholeness and that can bring about change." As Candide replied to Pangloss, "we must cultivate our garden."[65] The garden is the Self.

Notes

All statements by the artist are from conversations and correspondence between her and the author from June 1991 to October 1992.

1. Merry A. Foresta and Joshua P. Smith, *The Photography of Invention: American Pictures of the 1980s* (Washington, D.C.: Smithsonian Institution, 1989). This publication and traveling exhibition, organized for the National Museum of American Art, included the works of Jo Ann Callis, Bruce Charlesworth, Eileen Cowin, Stephen Frailey, Sandra Haber, Frank Majore, Patrick Nagatani, Lucas Samaras, John Schlesinger, Cindy Sherman, Laurie Simmons, Sandy Skoglund, and Joel-Peter Witkin, among others.

2. Marcel Proust, in *The Sweet Cheat Gone* (p. 362), reproduced in Howard Moss, *The Magic Lantern of Marcel Proust* (New York: The Macmillan Company, 1962), p. 1.

3. Ibid., p. 2.

4. Ibid., pp. 3—5.

5. Ibid., pp. 8—9.

6. Daniel Goleman, Paul Kaufman, and Michael Ray, *The Creative Spirit* (New York: Penguin Books, USA, Inc., 1992), p. 46. "The Creative Spirit" television series, a production of Alvin H. Perlmutter, Inc., was presented by WETA, Washington, D.C., for broadcast on PBS. Daniel Goleman is a psychologist who covers the behavioral sciences for *The New York Times*. Author of seven books, he has received numerous awards for his writing, including a Lifetime Achievement Award from the American Psychological Association. Paul Kaufman is the creator, writer, and senior producer of "The Creative Spirit" television series. A veteran documentary filmmaker, he recently produced and wrote "The Truth About Lies," part of the Peabody Award-winning series "The Public Mind." Michael Ray holds the McCoy-Banc One Chair of Creativity and Innovation at Stanford University's Graduate School of Business.

7. Mihaly Csikszentmihalyi, *Flow: The Psychology of Optimal Experience* (New York: Harper & Row, Publishers, Inc., 1990), p. 4. Although quite different from the yogi disciplines in India, the Taoist approach to life developed in China, and the Zen varieties of Buddhism, the state of flow is common to these practices in that it frees consciousness from the deterministic influences of outside forces (p. 20). The original research and the theoretical model of the flow experience were first fully reported in Csikszentmihalyi's *Beyond Boredom and Anxiety* (1975). Since then a great number of works have used the flow concept, and extensive new research has been accumulating, e.g., Silvano Arieti, *Creativity, The Magic Synthesis* (New York: Basic Books, Inc., Publishers, 1976). Arieti (American, b. 1914 in Italy), the esteemed psychiatrist, psychoanalyst, and author, started working at a clinical level with observations on and therapeutic dealings with the seriously mentally ill as well as with creative people. Later he studied creative products in various fields, such as poetry, art, and science in order to identify specific cognitive mechanisms common to the creative process. In *Creativity, The Magic Synthesis*, he has written that man's spontaneity and originality manifest themselves in a flow of images, feelings, and ideas (p. 6).

8. Bill Brandt, "A Photographer's London," in *Camera in London* (London, 1948), p. 14.

9. The quotations by Mary Blanchard Thorne-Thomsen are taken from a catalogue produced to accompany the December 3—28, 1982, exhibition of Ruth Thorne-Thomsen's family photographs at the now defunct NAB Gallery, then located at 331 South Peoria in Chicago. James Jensen, ed., *Mother & Daughter: A Family Album by Ruth Edwards and Mary Thorne-Thomsen* (Chicago: NAB Gallery, 1982), p. 7.

10. These first two verses of C. P. Cavafy's poem "Ithaca" are taken from *The Complete Poems of Cavafy*, trans. Rae Dalven, intro. by W. H. Auden (New York: Harcourt, Brace, Jovanovich, 1976), p. 36.

11. Naomi Rosenblum, *A World History of Photography* (New York: Abbeville Press), pp. 34—35.

12. Ibid., p. 104. Rosenblum cites this book as the first commercially published album in France to be illustrated with photographs, issued by Gide and Baudry in 1852 with images from negatives made by Du Camp; see Isabelle Jammes, *Blanquart-Evrard et les origines de l'édition photographique français* (Geneva, 1981), p. 81. According to Nissan Perez, "Aimé Rochas, Daguerreotypist," *Image*, June 1970, p. 2, three photographs in this album were by Aimé Rochas, a French daguerreotypist traveling in the Near East at the same time. The metal plates were rephotographed on albumen-coated glass from which prints were made.

13. On page x in their book *Egypt and the Holy Land in Historic Photographs* (New York: Dover Publications, Inc., 1980), Julia Van Haaften and Jon E. Manchip White cite numerous works of the early daguerreotypists: J.B. Greene, a member of the Société Asiatique, who published *Le Nil* in 1854; Robert Murray, chief engineer to the Viceroy of Egypt, who displayed Egyptian photographs to great praise in 1858; Félix Teynard, who produced *L'Egyte et Nubie*, containing photographs made in 1851; Frank Haes, who reportedly made transparent stereos of Cairo before 1858; Félice Beato and his brother-in-law James Robertson, who photographed in Cairo and the vicinity in 1858—60; Francis Bedford, who accompanied the Prince of Wales on a goodwill tour through Egypt and the Holy Land in 1862; and Félix Bonfils, Antonio Beato, and Pascal Sébah, the dominant suppliers of souvenir photographs for the sophisticated tourist trade.

14. The aperture (f-stop) is determined by camera length and the diameter of the opening to the darkened chamber. A six-inch depth and a .018-inch diameter (equivalent to the size of a hole made with a #10 needle) will yield f/333. *Pinhole Journal* 5, 1 (Apr. 1989), inside cover.

15. Van Haaften and White (note 13), p. viii.

16. Ibid., p. xi.

17. *British Journal of Photography* 9 (Oct. 1, 1862), p. 368.

18. Robert Hershkowitz, *The British Photographer Abroad* (London: Robert Hershkowitz Ltd., 1980), p. 7. Hershkowitz is an American now living in Sussex. He has been involved with nineteenth-century photography for the past seventeen years as a freelance writer, collector, and dealer.

19. "Primitive" is used here to reference the early techniques that Thorne-Thomsen employed. The term was first defined by Robert Sobieszek, now curator of photography at the Los Angeles County Museum of Art, in the book he coauthored with André Jammes and Minor White, *French Primitive Photography* (New York: Aperture, Inc., 1970), unpag. Its meaning involves an aesthetic "directness," one of "straightforward immediacy." In the work of *primitives*, there is often a roughness or unevenness to their prints, or some flaw in the negatives, e.g., the effects of sand on the paper negatives of Ruth Thorne-Thomsen. Clearly, however, Thorne-Thomsen has transcended the *primitive* and has produced expressions of sophisticated aesthetic sensibility, not just the scenes before her.

20. This quotation is taken from the unnumbered page for plate 9 of *Egypt and the Holy Land in Historic Photographs* (note 13). In the description for plate 12, *The Great Pyramid*

and the Sphinx, Jon E. Manchip White, Lindsay Young Professor of the Humanities and Professor of English at the University of Tennessee in Knoxville, writes: "The Greek Sphinx, a winged lioness, was a sinister deity who became confused with the generally beneficent Egyptian *sheshpankh*, or 'living statue,' because of the similarity in the sound of their names. The Egyptian Sphinx was a common emblem of royal potency, a lion with the bearded head of a king or of the sun god. It figured prominently in the approaches to temples. The Great Sphinx at Giza was carved by order of Pharaoh Khafra from a knob of rock left in the quarry from which came the blocks that formed the core of his pyramid. Its worn and blunted features are the result not only of the abrasive action of the sand but of the pockmarks caused by the bullets of the Ottoman rulers' Turkish janizaries, who used it for target practice.... Four hundred and ninety feet high. Two million three hundred thousand blocks of stone, each averaging two and a half tons. A base that covers an area of 31 acres. An interior threaded by a corridor leading to a Queen's Chamber, and a Grand Gallery leading to a King's Chamber, the latter a huge granite room corbeled with seven granite slabs in which reposes a massive royal sarcophagus (alas, empty — looted or never used). Add to all this the fact that the whole exterior was once faced (now only meagerly) with smooth, dazzling slabs of limestone between whose thousandth-of-an-inch joints not even the blade of a knife can be inserted. Truly the sepulchre or cenotaph of a mighty king."

21. In writing on the technique, Jacques B. Brunius, a practitioner of Surrealist collage, suggested the word *rencontre* (encounter) instead of collage because it highlights the *effects* of the technique versus the method by which the pictures are made. Jacques B. Brunius, "Rencontres fortuites et concertées," in E.L.T. Mesens, *125 Collages et Objets* (Knokke-le-Zoute, Belgium, July-Aug. 1963).

22. Novalis, *Neue Fragmente*, no. 259, in Werner Spies, *Max Ernst: Collages, The Invention of the Surrealist Universe*, trans. John William Gabriel (New York: Harry N. Abrams, Inc., Publishers, 1988), p. 11.

23. In J.E. Cirlot's *A Dictionary of Symbols* (New York: Dorset Press, 1971), p. xxxi, René Guénon points out: "The true basis of symbolism is...the correspondence linking together all orders of reality, binding them one to the other, and consequently extending from the natural order as a whole to the supernatural order. By virtue of this correspondence, the whole of Nature is but a symbol, that is, its true significance becomes apparent only when it is seen as a pointer which can make us aware of supernatural or 'metaphysical' truths — metaphysical in the proper and true sense of the word, which is nothing less than the *essential function of symbolism*...."

24. Goleman et al. (note 6), p. 47.

25. James Hall, *Dictionary of Subjects and Symbols in Art* (New York: Harper & Row, Publishers, Inc., 1974), p. 157, and Cirlot (note 23), p. 152.

26. Mary Ann Caws, Rudolf E. Kuenzli, and Gwen Raaberg, eds., *Surrealism and Women* (Cambridge: The Massachusetts Institute of Technology Press, 1991), p. 160.

27. Cirlot (note 23), p. 152.

28. Caws et al. (note 26), p. 160.

29. J. Huizinga, *Homo Ludens* (Boston: Beacon Press, 1967), p. 10.

30. A quotation from Hans-Georg Gadamer's essay "The Play of Art," in *The Relevance of the Beautiful and Other Essays*, trans. Nicholas Walker, ed., intro. by Robert Bernasconi (New York: Cambridge University Press, 1991), p. 127.

31. Huizinga (note 29), p. 10.

32. J.H. Matthews, *The Imagery of Surrealism* (Syracuse, New York: Syracuse University Press, 1977), p. 87.

33. Gudrun Thorne-Thomsen, "Goomie," read folktales to her grandchildren about Norway, Thorne-Thomsen's paternal national heritage. Quite renowned for her spell-binding narration, Gudrun taught at the Francis Parker School in Chicago, then served as the principal of the Ojai Valley New School in California. She is the author of *In Norway* and *The Sky Bed: a Norwegian Christmas*. As an aside, it may be interesting to the reader to know that her portrait was made while she was at the New School by Edward Weston (American, 1886–1958) when he was an itinerant photographer.

Essentially, folktales are the same the world over, however, the motifs, characters, atmosphere, and style are "cultivated" to the international locales. Norwegian folktales contain "an undertone of realism and folk humor that makes them unique; they reflect the tremendous imagination of the people as well as their independence and self-reliance." In the essay "The Norwegian Folk Tales and Their Illustrators," Pat Shaw reveals that "the tales, or *eventyr* as they are called, wandered to Norway probably during the Middle Ages. They were absorbed into the existing lore, undergoing constant change through generations of storytelling.... Rural life in Norway has always been centered in the family farms — small isolated communities, often surrounded by great forests, and high mountains. There, according to Werenskiold's description of his childhood home, 'one sat in the darkness by the oven door...from the time of the tallow candle and the rush light ...in the endless, lonely winter evenings, where folk still saw the *nisse* and captured the sea-serpent, and swore it was true'" (Peter Christen Asbjornsen and Jorgen Moe, *Norwegian Folk Tales* [New York: Pantheon Books, 1960], p. 5).

The fairy tales of the Brothers Grimm, among the first to transcribe folktales, included the classic fable *Tom Thumb*: "A Poor Peasant sat one evening by his hearth and poked the fire, while his Wife sat opposite spinning. He said: 'What a sad thing it is that we have no children; our home is so quiet, while other folk's houses are noisy and cheerful.' 'Yes,' answered his Wife, and she sighed; 'even if it were an only one, and if it were no bigger than my thumb, I should be quite content; we would love it with all our hearts.' Now, some time after this, she had a little boy who was strong and healthy, but was no bigger than a thumb. Then they said: 'Well, our wish is fulfilled, and, small as he is, we will love him dearly'; and because of his tiny stature they called him Tom Thumb." The story continues with the travels of young Tom Thumb, "down a mouse-hole, in a Cow's stomach, and in a Wolf's maw," and ends with the return of the son to his loving parents, who will never again sell him "for all the riches in the world" (Jakob Ludwig Karl and Wilhelm Grimm, *Grimm's Fairy Tales, Twenty Stories* [New York: The Viking Press, 1973], p. 91).

34. Tomas Hutchinson, ed., *The Complete Poetical Works of Percy Bysshe Shelley* (London: Oxford University Press, 1965), p. 550.

35. Van Haaften and White (note 13), unpag., pl. 30.

36. Desmond King-Hele, *Shelley, The Man and the Poet* (New York: Thomas Yoseloff, Publisher, 1960), p. 94. See also A.M.D. Hughes, *Shelley, poetry and prose*, pp. 189–90, for the reference to the quotation from Diodorus Siculus as a sign of Shelley's growing interest in things Greek.

37. In *Atget's Gardens* (New York: Doubleday & Company, Inc., 1979), p. 10, author William Howard Adams, a senior member of the staff of the National Gallery of Art and author of *The French Garden, 1500–1800*, makes note of the American photographer Berenice Abbott's reference to Atget's learning about the medium of photography in the gardens

in and around Paris: "...when Atget gave up the theater at the age of forty, in 1897, deciding to learn a new profession, he used the out-of-the-way châteaux and their parks on the outskirts of the city as a studio. He could experiment without interference by the curious or suspicious." The photographs Atget made in the gardens were most often supplied to artists looking for subject matter for paintings.

38. Arthur A. Cohn, novelist, essayist, and theologian, has written extensively on modern art. In *Herbert Bayer, The Complete Work* (Cambridge: The MIT Press, 1984), he describes Bayer's *Metamorphose* (Metamorphosis) as "one of the most widely reproduced examples of Bayer's graphic design" (p. 281). It was used as the cover for the 1928 *Bauhaus Zeitschrift*. The cube, the ball, and cone became "his personal shorthand for the Bauhaus aesthetic." Cohn writes: "In *Metamorphose* Bayer has arranged a processional of these elements, moving out of an airbrushed cave of darkness toward a vista of trees, ocean, and cloud-filled sky. The marble creatures of geometry, the building blocks of nature, are on the move from darkness to their transformation by sunlight into the materials of creation. This Fotoplastik is an integral metaphor: nothing needs to be added or removed for it to suggest a wealth of meanings abundant beyond its simplicity of means."

39. This quotation includes the last stanza in Hart Crane's poem "Emblems of Conduct," from *The Complete Poems and Selected Letters and Prose of Hart Crane*, ed. with an intro. and notes by Brom Weber (New York: Anchor Books, 1966), p. 5.

40. Joseph Campbell, *The Mythic Image* (Princeton, New Jersey: Princeton University Press, 1974), p. xi.

41. *Guardian* press quotation reprinted on the back cover of the paperback *Man and His Symbols*, ed. with an intro. by Carl G. Jung (New York: Dell Publishing, 1968).

42. Ibid., p. x. John Freeman makes this reference to Jung's emphasis on dreams in the introduction.

43. Ibid., p. 57.

44. Ibid., pp. 42—43.

45. Ibid., p. 4.

46. Cirlot (note 23), p. 161.

47. The *Door* series was completed during the three weeks Thorne-Thomsen spent in Door County in 1983; however, because of their symbolic qualities, the photographer reintroduced into this series the photographs *Monolith, California*, 1981, and *2-Face, California*, 1982. The phallic *Monolith*, for example, may be allied with the Celtic stones that were used singly as grave markers, or to the Greek *hermae* stones set up on roadsides and boundaries, both markers of sorts to other types of passageways.

48. Metzker's work would also change significantly during this period, perhaps influenced not only by the beckoning of a new format and new subject matter, but also unconsciously by the sensuality of Thorne-Thomsen's landscapes. Coming to a conclusion on *City Whispers*, Metzker put down his 35mm camera and picked up a 2-and-a-¼ inch to photograph around the olive grove on the Tuscany hillside — photographs of the land versus city streets.

49. *Prima materia* (Latin for first material) is also an alchemical term used by Jung. In *The Archetypes and the Collective Unconscious*, trans. R.F.C. Hull (Princeton, New Jersey:

Princeton University Press, 1990), p. 304, he writes: "...[intuition] hits consciousness unexpectedly, like lightning, and occasionally with devastating consequences. It thrusts the ego aside and makes room for a supraordinate factor, the totality of a person, which consists of conscious and unconscious and consequently extends far beyond the ego. This self was always present...but sleeping, like Nietzsche's 'image in the stone.'... It is, in fact, the secret of the stone, of the *lapis philosophorum*, in so far as this is the *prima materia*. In the stone sleeps the spirit *Mercurius*, the 'circle of the moon,' the 'round and square,'...the homunculus, Tom Thumb and Anthropos at once,...whom the alchemists also symbolized as their famed *lapis philosophorum*...."

50. The "Gaia hypothesis" was first advanced in 1972 by the unorthodox British chemist and inventor James Lovelock, but is now most associated in the United States with Lynn Margulis, Distinguished Professor of Botany at the University of Massachusetts at Amherst, with whom Lovelock began collaborating in 1974. The April 19, 1991, *Science* article "Lynn Margulis: Science's Unruly Earth Mother" includes the following: "Because, in Margulis' view, symbiosis is the major force behind evolution, the unit of biological study is not the individual but the symbiotic system, which is primarily characterized by the property of 'autopoiesis'—a relatively obscure term that means 'self-maintenance.' Autopoietic systems conserve their boundaries and regulate their biochemical compositions. Most are capable of reproduction; some are not. Some things that reproduce, such as viruses, are not autopoietic, because they are too simple to maintain themselves biochemically. The smallest autopoietic entity is the bacterial cell. The largest, Margulis says, is Earth. By contrast to Mars and Venus, Earth has a surprisingly alkaline surface and a chemically unstable atmosphere, with abnormally high levels of nitrogen, oxygen, methane, hydrogen, ammonia, and other gases. 'Lovelock's concept, with which we entirely agree,' Margulis and a former student, Gregory Hinkle, write in *Scientists on Gaia*, 'is that the biota (the sum of all the live organisms at any given time), interacting with the surface materials on the planet, maintains these particular anomalies of temperature, chemical composition, and alkalinity.' In Margulis' view, Earth is a 'single enormous system deriving from a 3,500-million-year-old common ancestor'" (pp. 379—80).

51. Giorgio de Chirico, "On Metaphysical Art" (1919). Originally published as "Sull'arte metafisica," in *Valori Plastici* (Rome) I, 4—5 (Apr.—May 1919), pp. 15—18. This translation is by Joshua C. Taylor in Herschel Browning Chipp, *Theories of Modern Art* (Berkeley: University of California Press, 1968), pp. 449—50.

52. Merry Foresta, Stephen C. Foster, Billy Klüver, Julie Martin, Francis Naumann, Sandra S. Phillips, Roger Shattuck, and Elizabeth Hutton Turner, *Perpetual Motif: The Art of Man Ray* (New York: Abbeville Press, 1988), p. 266.

53. From a review of Ruth Thorne-Thomsen's work at the now-defunct Marcuse Pfeifer Gallery in New York by Charles Hagan in *Artforum* 26, 6 (Feb. 1988), p. 141.

54. *Webster's Ninth New Collegiate Dictionary* (New York: Merriam-Webster, Inc., 1984), pp. 743, 799; *Dictionary of Foreign Phrases and Abbreviations* (New York: The H.W. Wilson Company, 1987), p. 86.

55. The noted scholar Kenneth Clark writes that Leonardo da Vinci's Leda symbolizes "the female aspect of creation. She is a fertility goddess, a Diana of Ephesus, her female attributes emphasized not by monstrous exaggeration, but by ingenuity

of pose. The downcast eyes, taken by Lomazzo as a sign of modesty, are dark, secret, remote. Even those elaborate coils of hair seem appropriate to the intricacy of conception. All round this passive figure, nature is bursting with new life, thick grasses writhe out of the earth, thick leaves weigh down the branches..." (Kenneth Clark, *Leonardo da Vinci, An Account of His Development as an Artist* [New York: Penguin Books Ltd., 1980], p. 117).

56. Giorgio de Chirico, "Mystery and Creation" (1928). Originally published in André Breton, *Le Surréalisme et la Peinture* (Paris: Gallimard, 1928), pp. 38–39. This English translation is from *London Bulletin* 6 (Oct. 1938), p. 14.

57. Jung (note 41), p. 37. Jung writes: "For the sake of mental stability and even physiological health, the unconscious and the conscious must be integrally connected and thus move on parallel lines. If they are split apart or 'dissociated,' psychological disturbance follows. In this respect, dream symbols are the essential message carriers from the instinctive to the rational parts of the human mind, and their interpretation enriches the poverty of consciousness so that it learns to understand again the forgotten language of the instinct."

58. Ibid.

59. Charles Baudelaire quoted in Eugenia Parry Janis, *The Photography of Gustave Le Gray* (Chicago: The Art Institute of Chicago and The University of Chicago Press, 1987), p. 61.

60. Ibid., p. 83.

61. Alev Lytle Croutier, *Taking the Waters* (New York: Abbeville Press, 1992), p. 47.

62. Joy Kenseth, ed., *The Age of the Marvelous* (Hanover, New Hampshire: Hood Museum of Art, Dartmouth College, 1991), pp. 161, 169, 401–402. *Il mondo festeggiante* was a festival staged in honor of the wedding of the son of Medici Grand Duke Ferdinand II — Prince Cosimo III — to an unwilling Marguerite Louise of Orléans in the chapel of the Louvre. It was originally published in Arthur R. Blumenthal, *Theater Art of the Medici* (Hanover, New Hampshire: Hood Museum of Art, Dartmouth College, 1980), pp. 183ff.

63. The final three verses of C. P. Cavafy's poem "Ithaca" (note 10), pp. 36–37.

64. Florence Hamlish Levinsohn, "Night Shift, A Contemporary Interpretation of Dreams: What do they accomplish? How do they work? Why are they so weird?" *Reader* 21, 31 (May 8, 1992), p. 23.

65. Lowell Blair, trans., *Candide by Voltaire* (New York: Bantam Books, 1959), p. 120.

Within this Garden

By Mark Strand

Very little could be said.
A shaft of sunlight struck the waves.
And floated there like fire.
An island took its place.

We stared ahead.
Birds offshore were blackening the air.
A rain of feathers fell along the beach.
Then blew away.

The sea's majestic moment was at hand.
A new plateau would come, and then another.
The falling waves would sound
Like a serenade for strings.

The day was almost done.
A row of palms had cast a turquoise shade
Beside the road. A man was sitting in his car
When a woman in a bathrobe wandered by.

And even then, very little could be said.
Later on, a cat began to cry.
The woman in the bathrobe and the man
Spoke quietly in bed.

And lo! The night was altered
By the weight of passion. Snow fell
Upon the breaking waves. The couple rose
And with a gesture slow enough to be sleep-filled

An arm was raised, and, just as slowly,
Eyes averted. And a voice that was no voice at all
Began to shape a scene that none
Could tell the ending of.

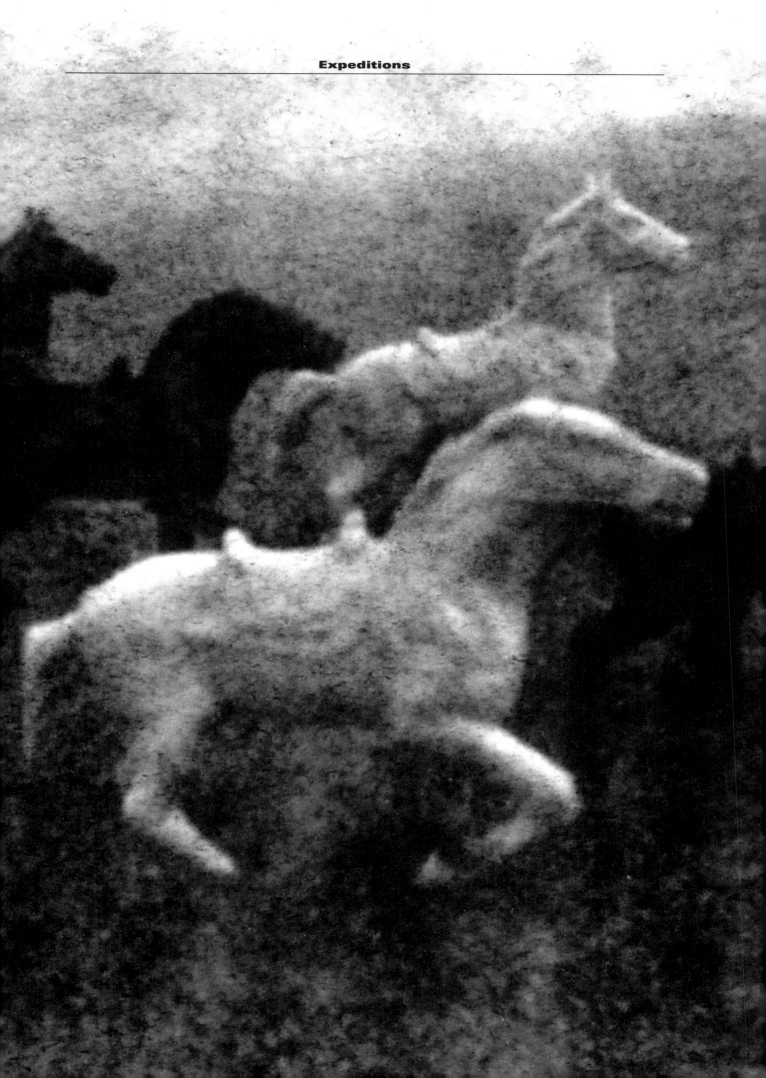

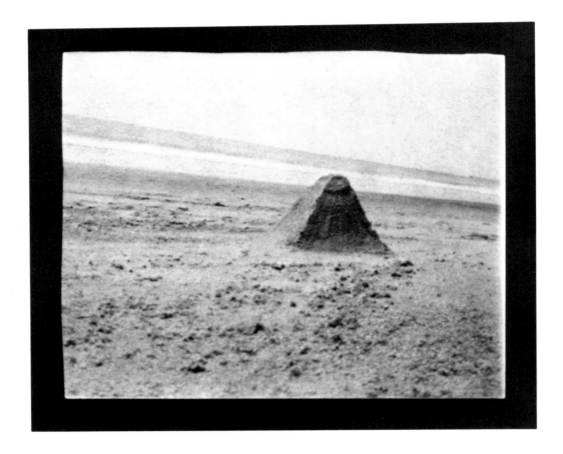

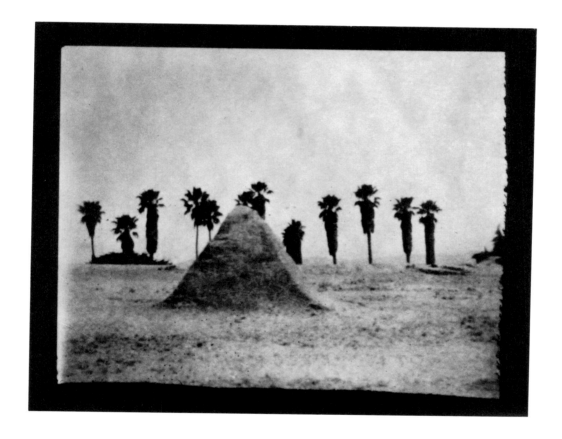

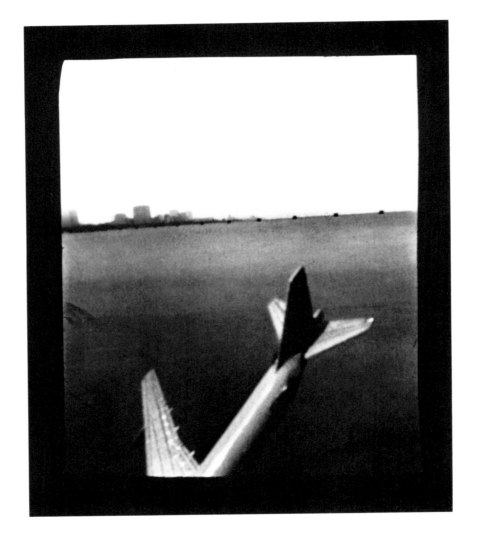

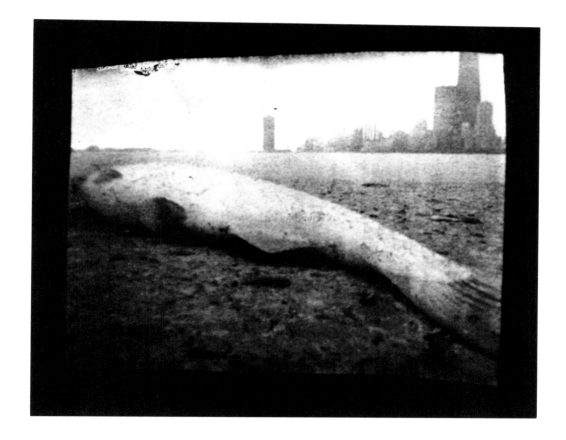

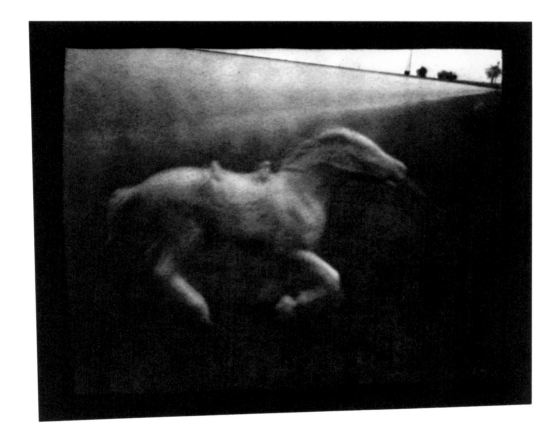

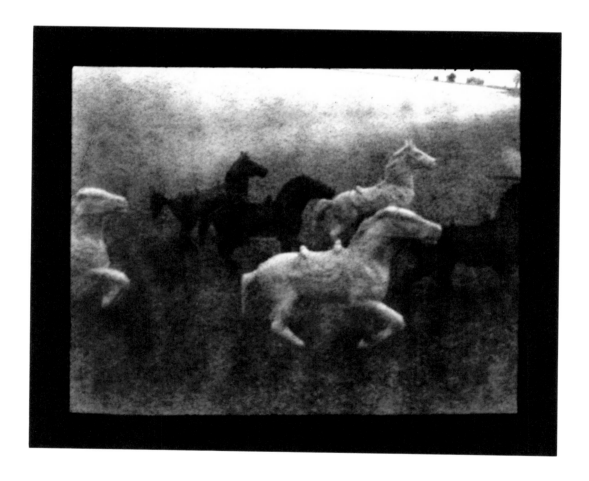

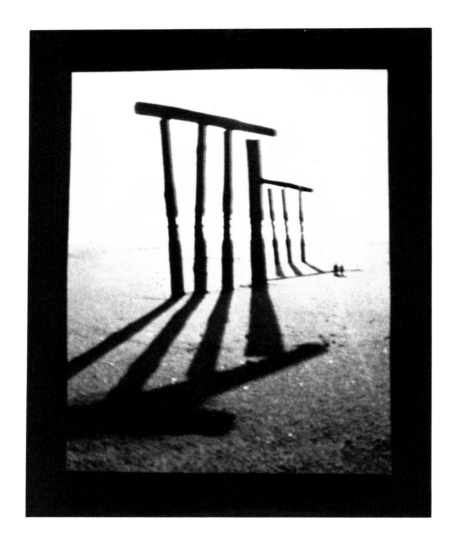

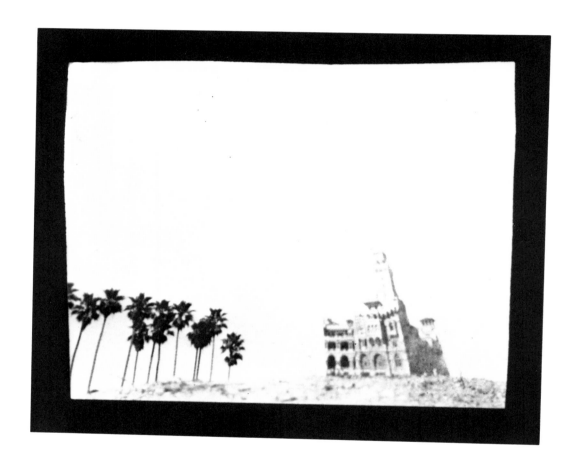

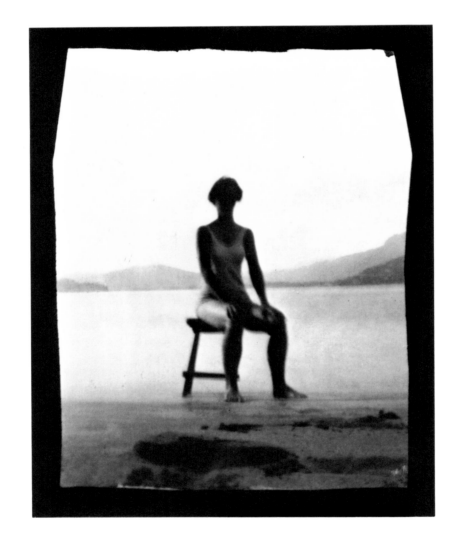

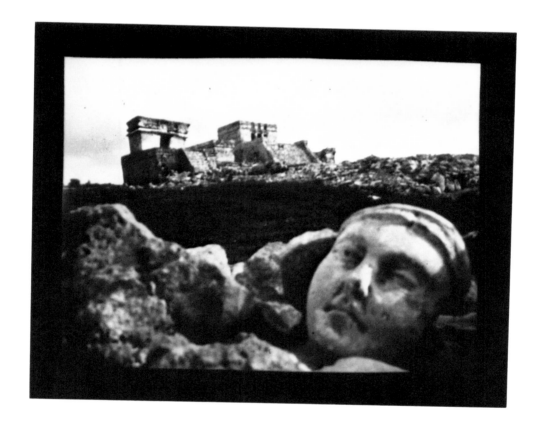

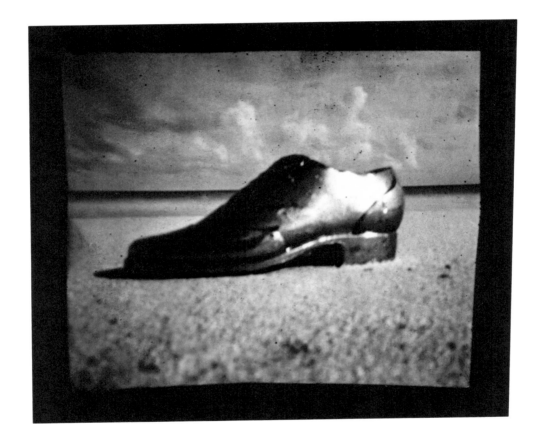

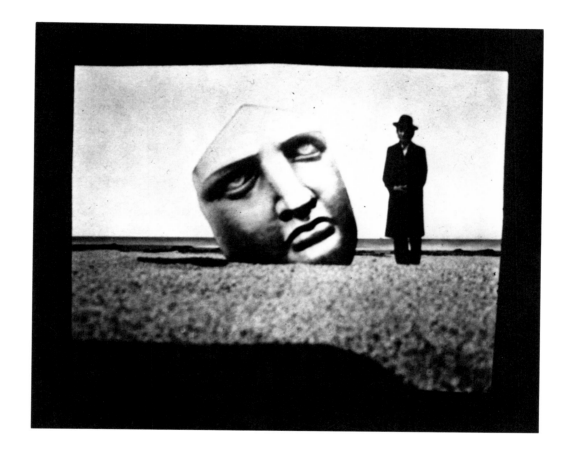

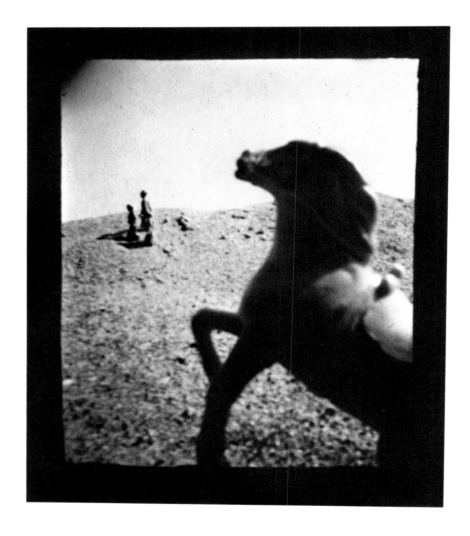

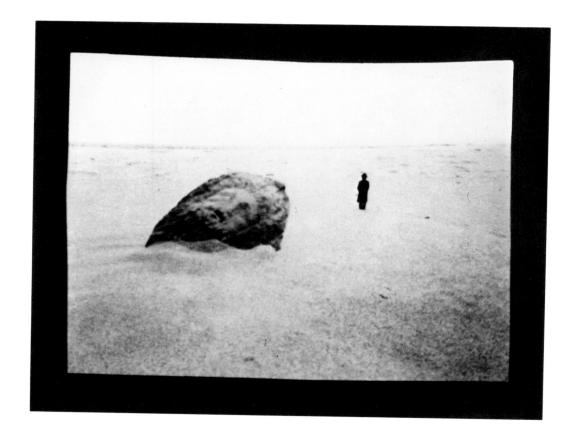

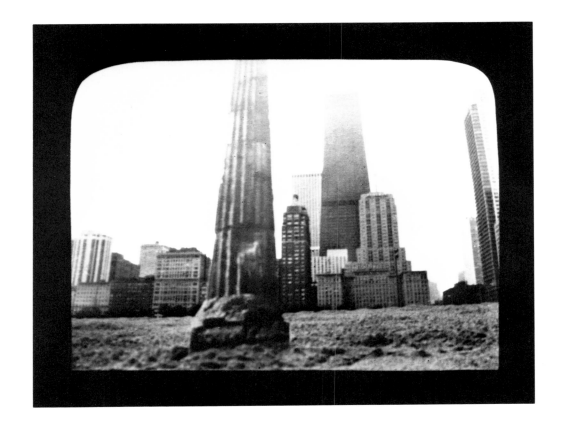

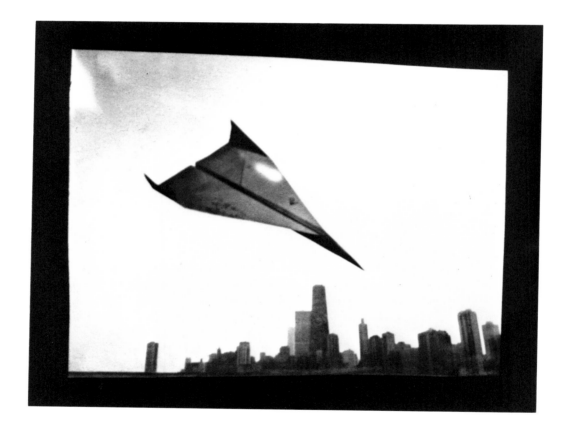

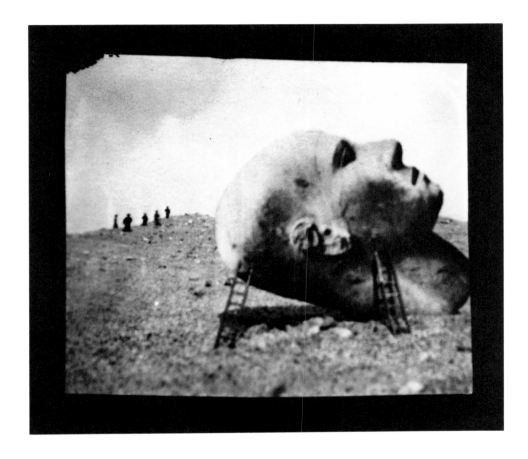

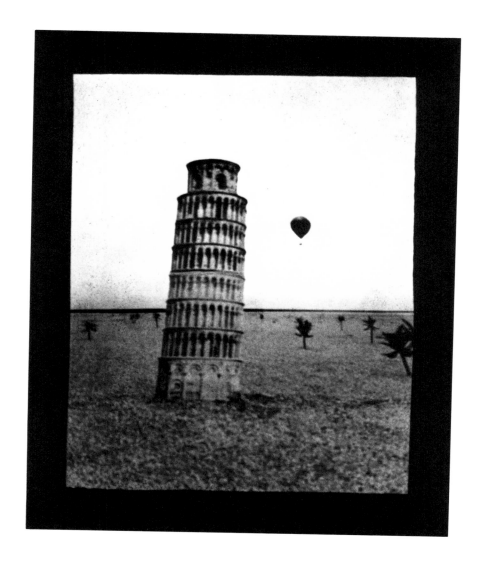

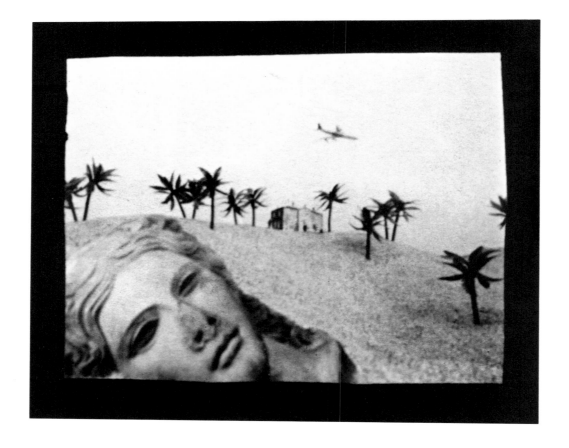

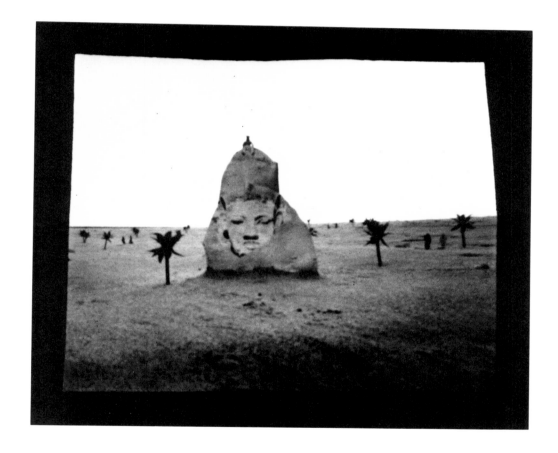

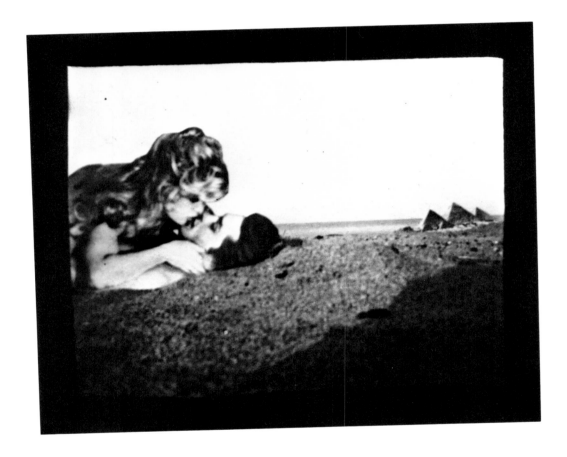

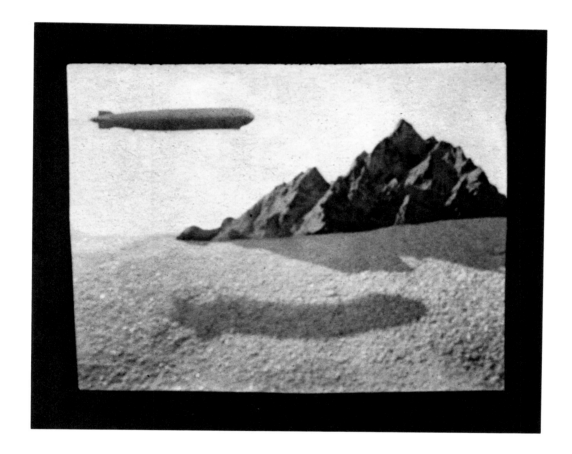

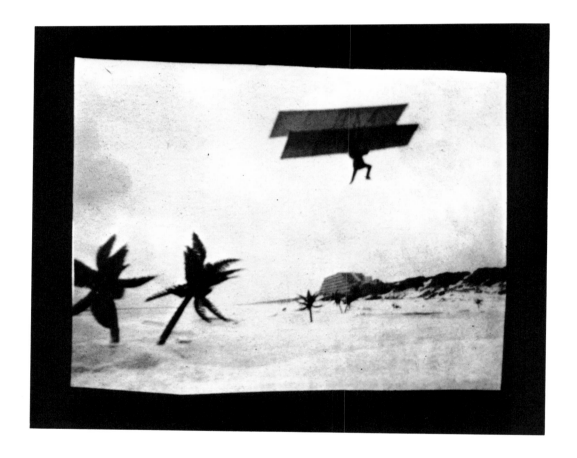

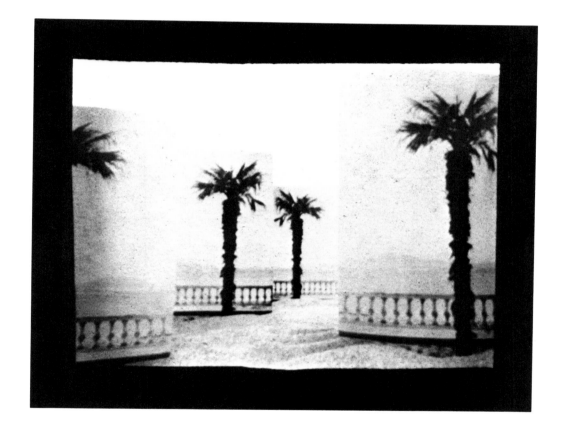

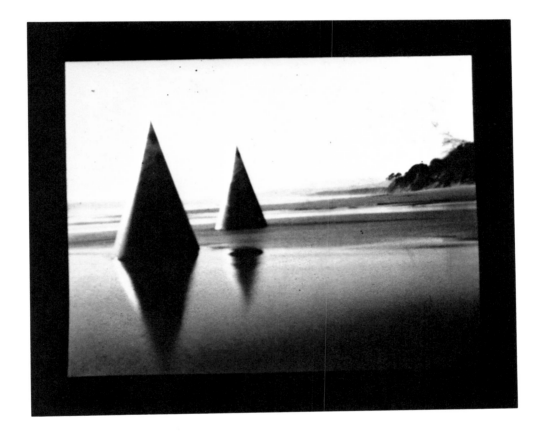

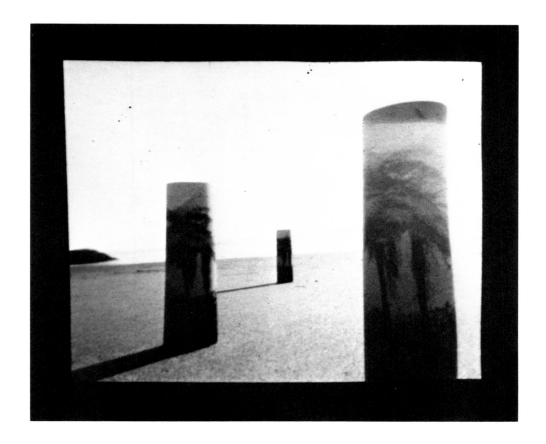

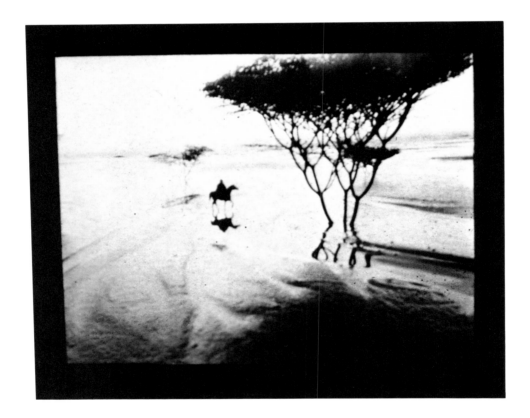

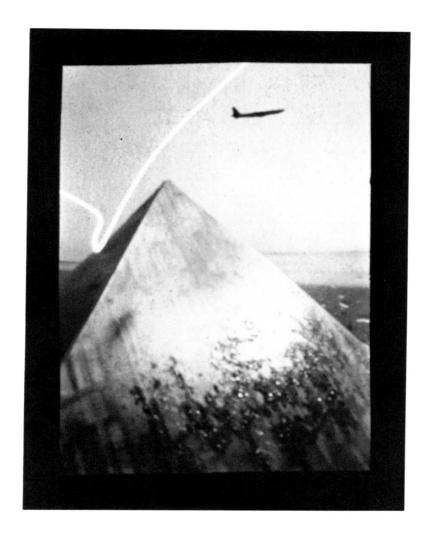

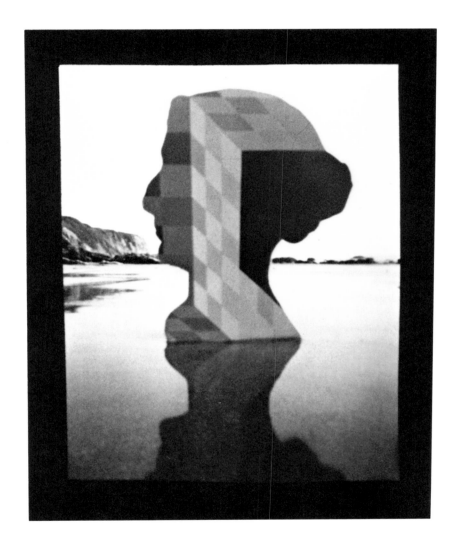

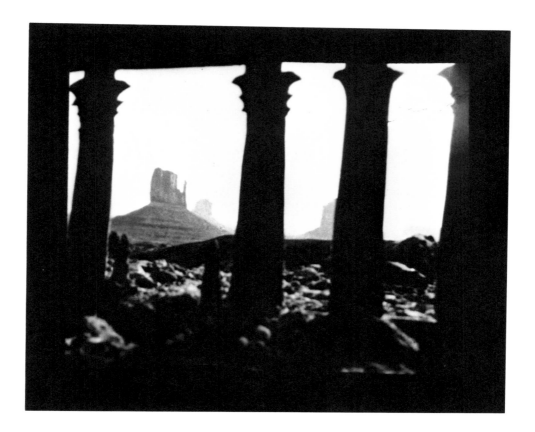

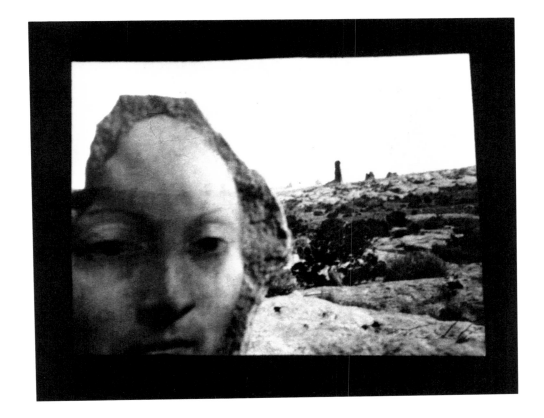

PAGE 81, PLATE 32, CAT. 32

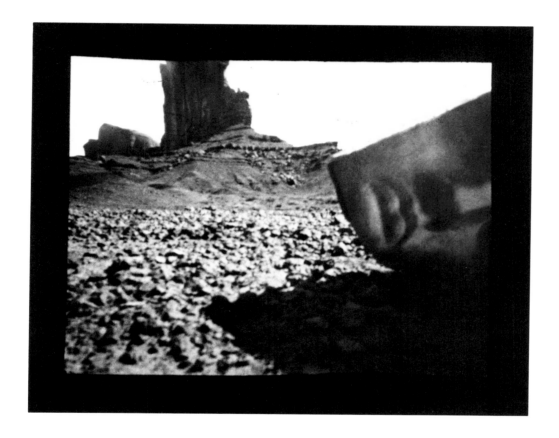

PAGE 82, PLATE 33, CAT. 33

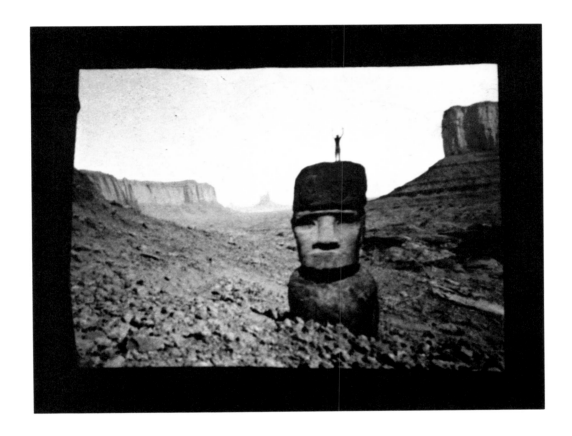

PAGE 84, PLATE 34, CAT. 35

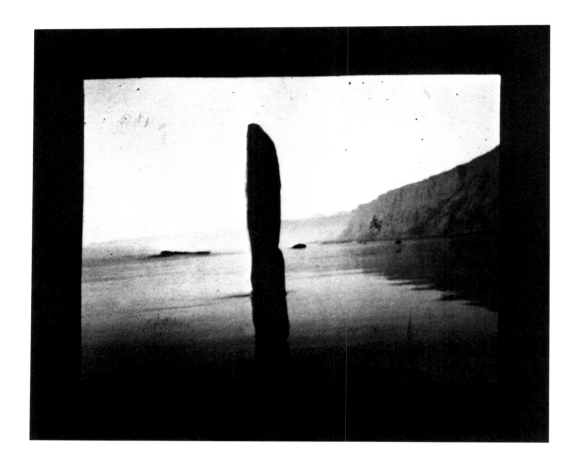

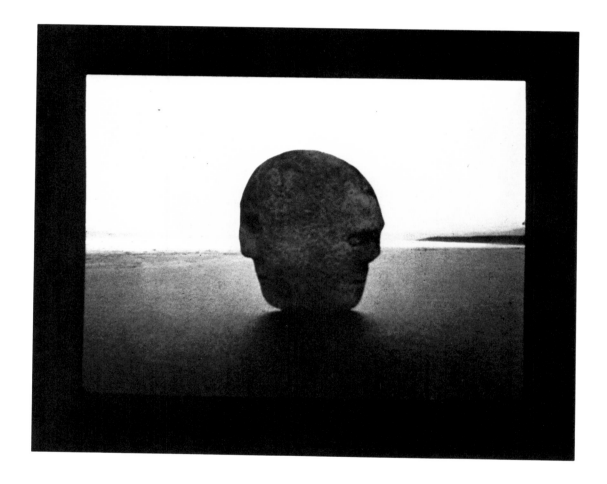

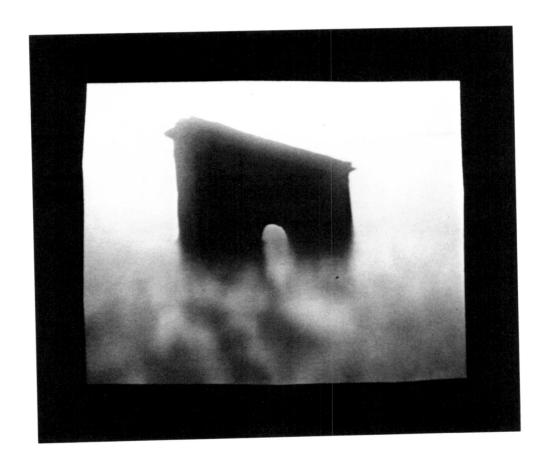

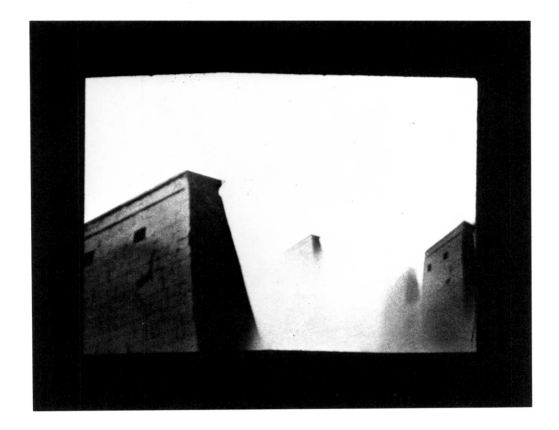

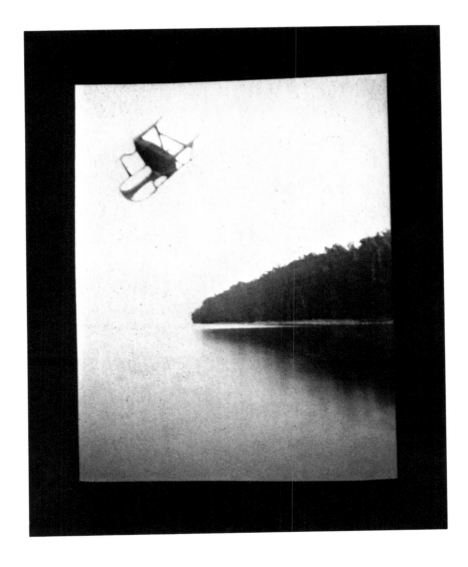

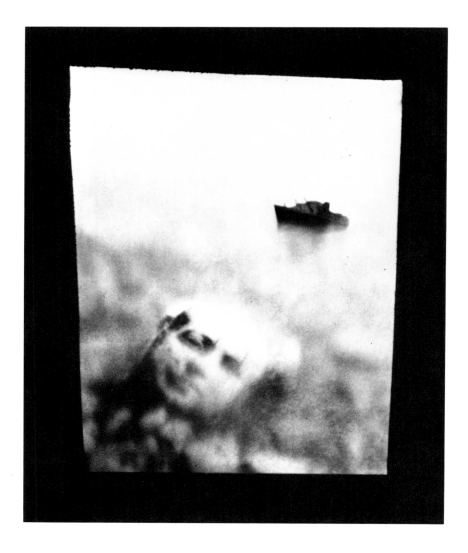

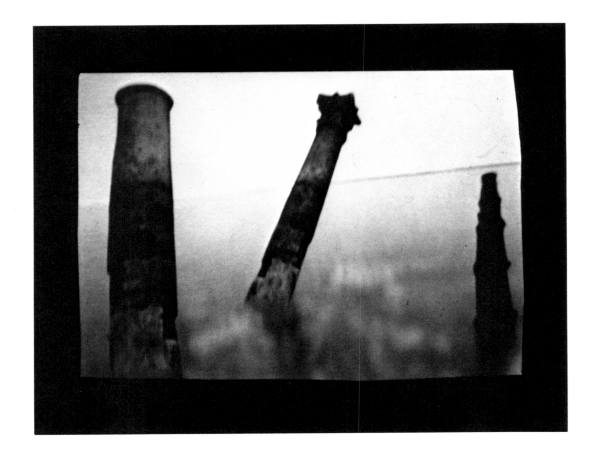

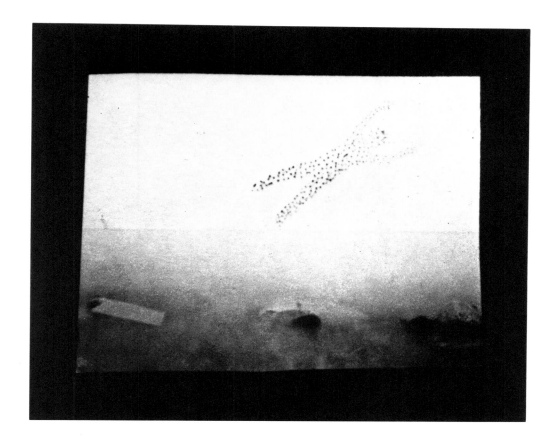

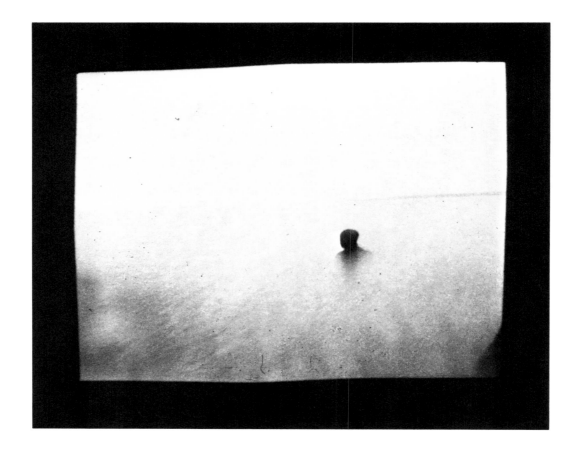

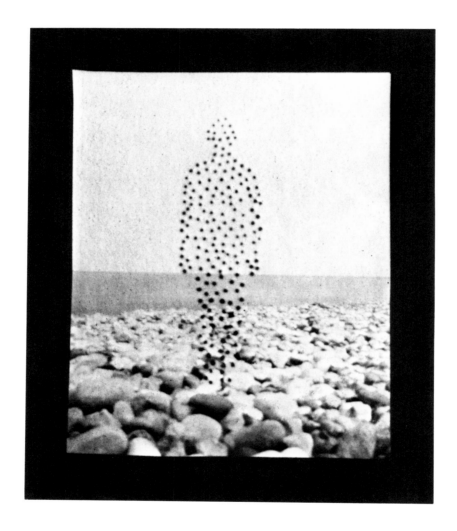

PAGE 94, PLATE 44, CAT. 44

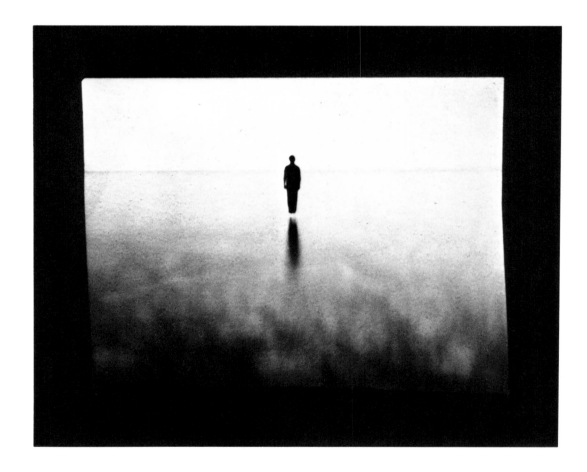

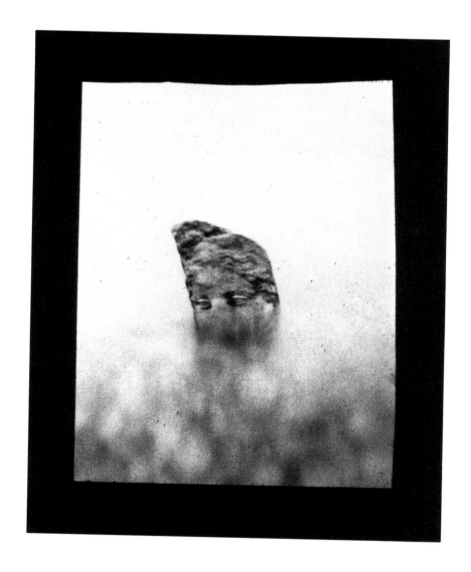

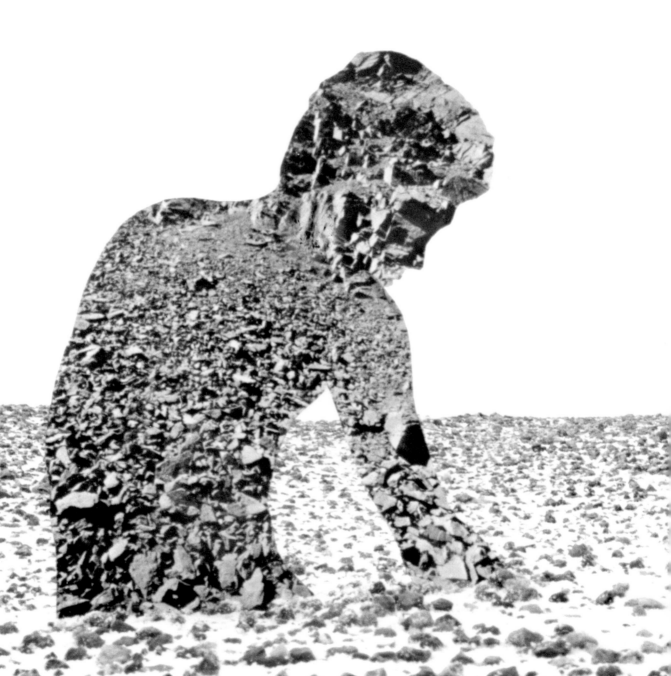

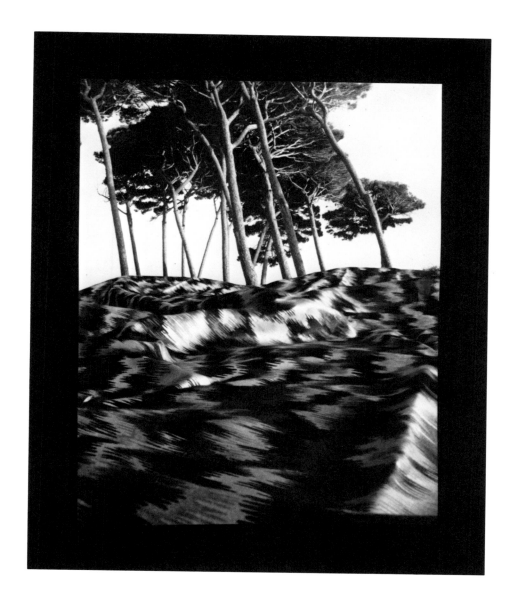

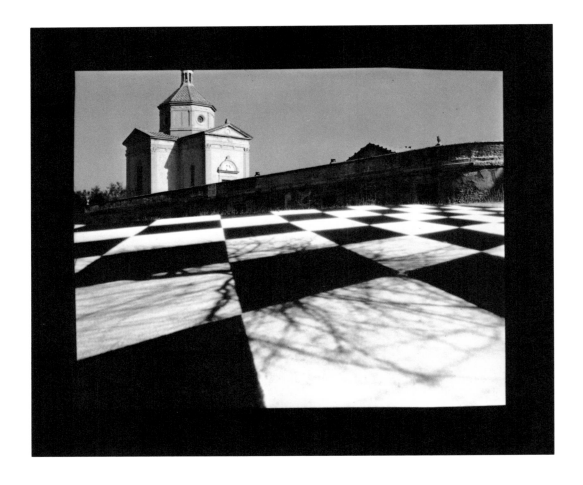

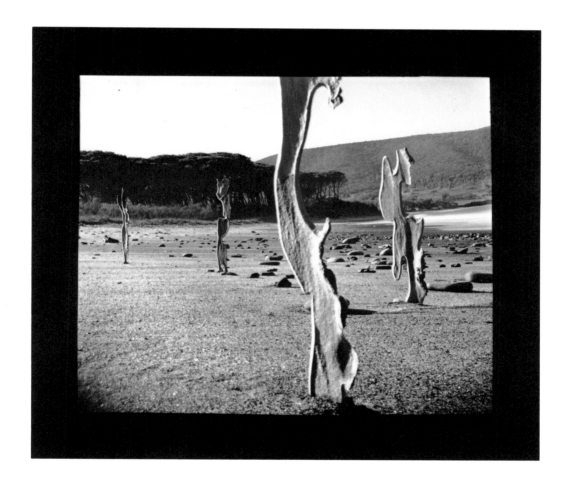

Puzzle, Italy, 1985

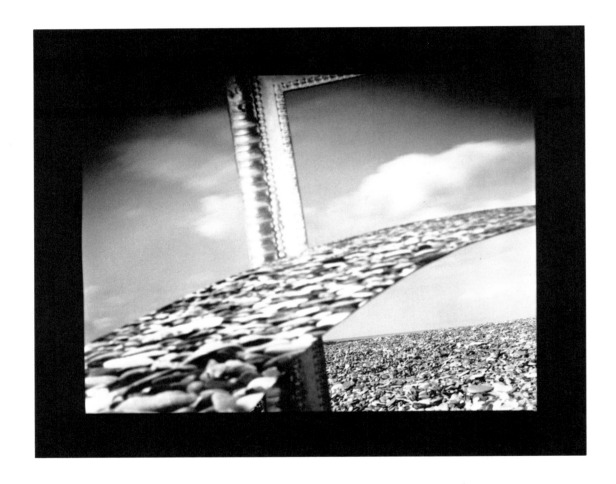

Pyramid, Italy, 1985

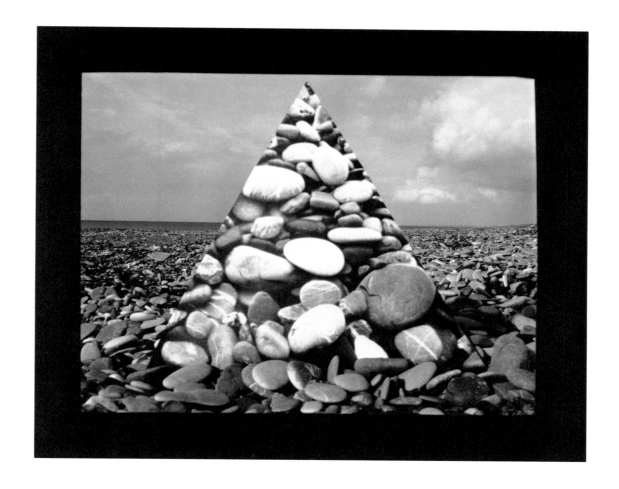

Pyramid, Italy, 1985

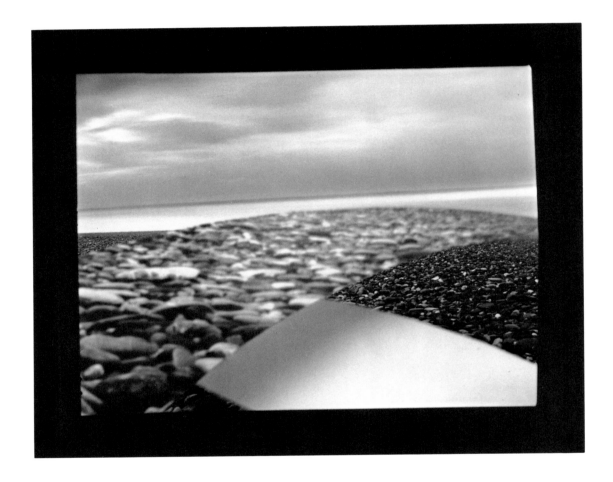

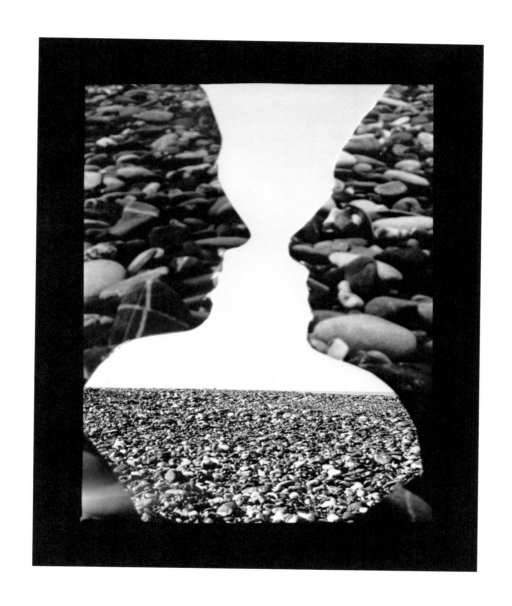

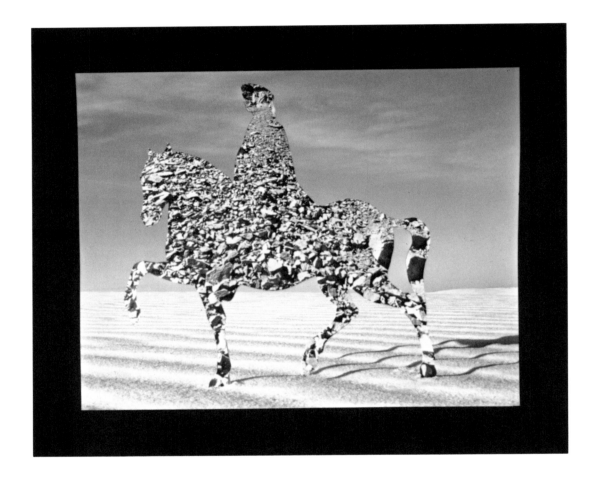

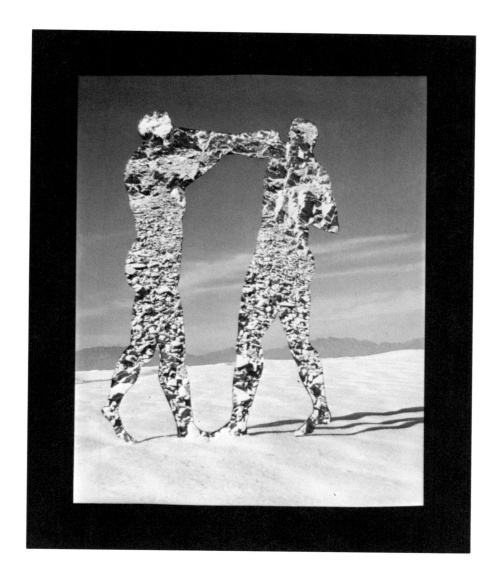

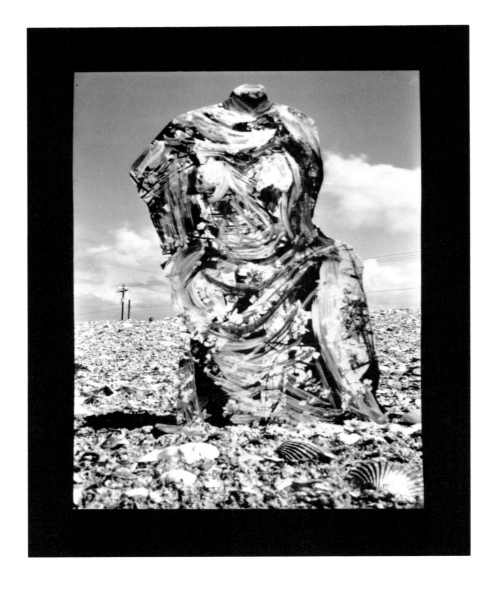

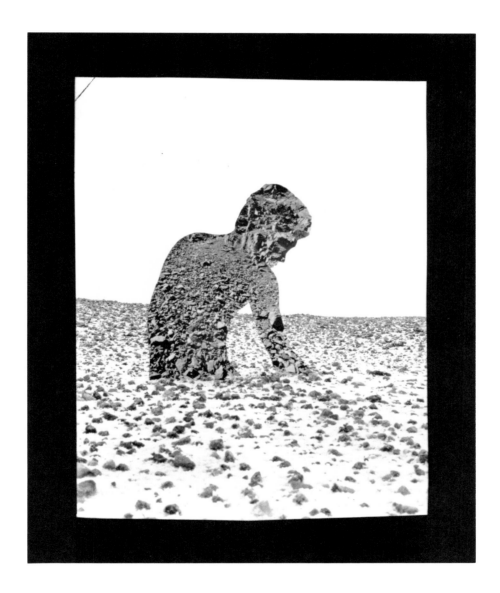

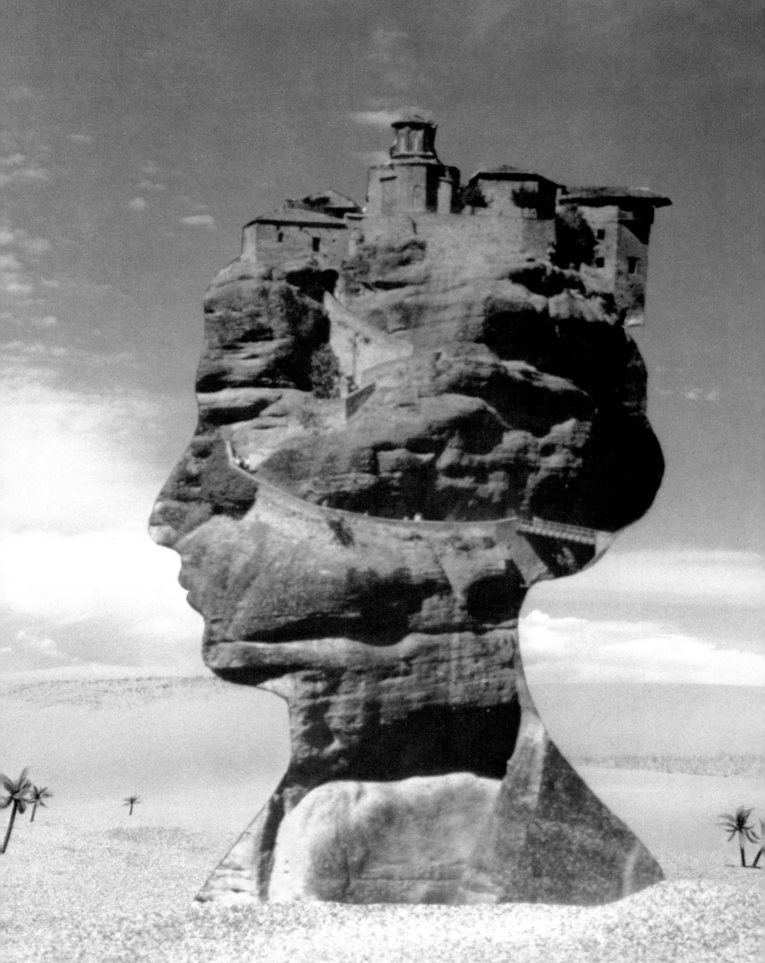

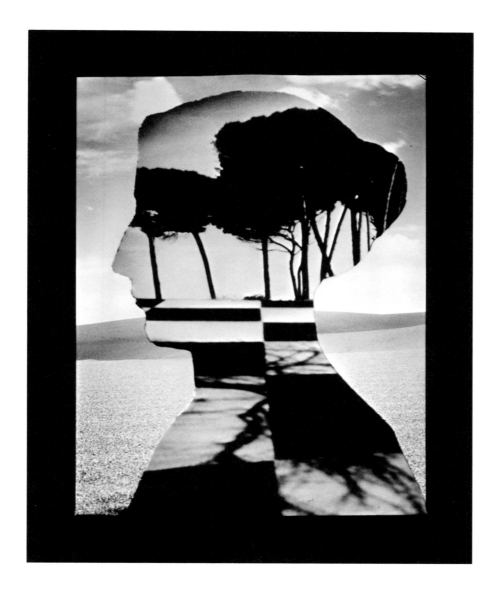

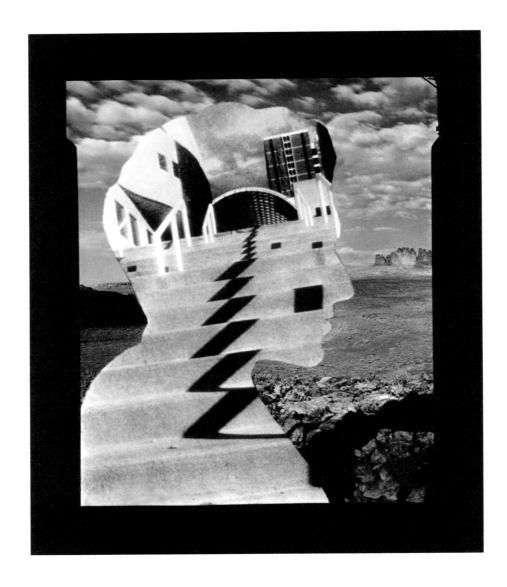

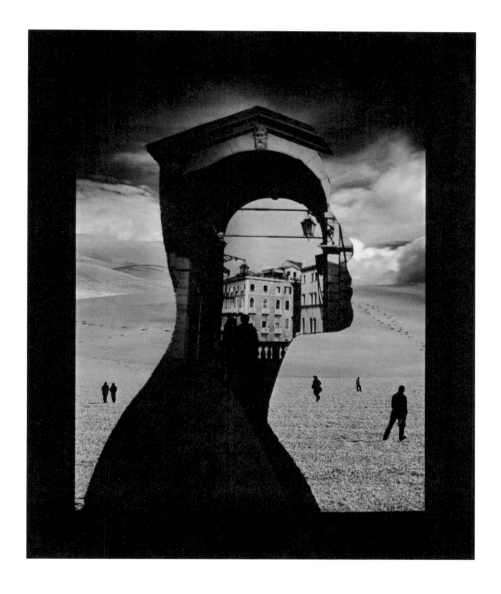

PAGE 112, PLATE 60, CAT. 64

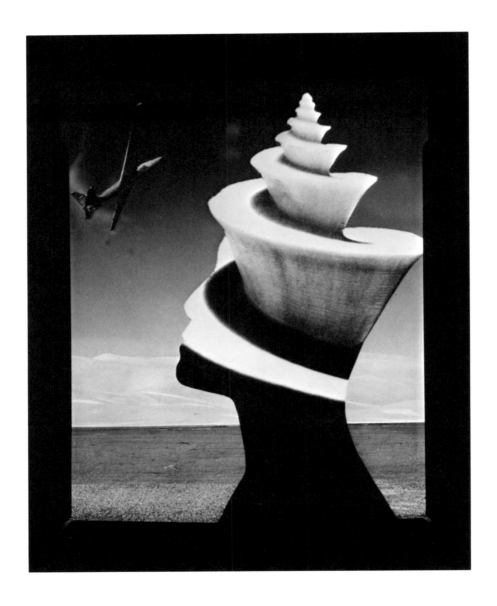

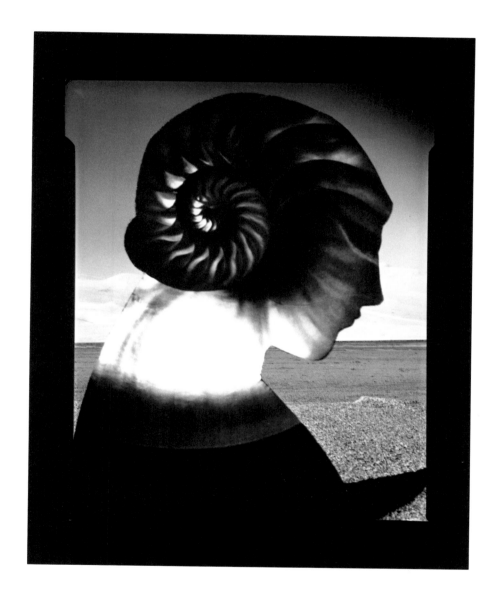

Leda, Colorado, 1986

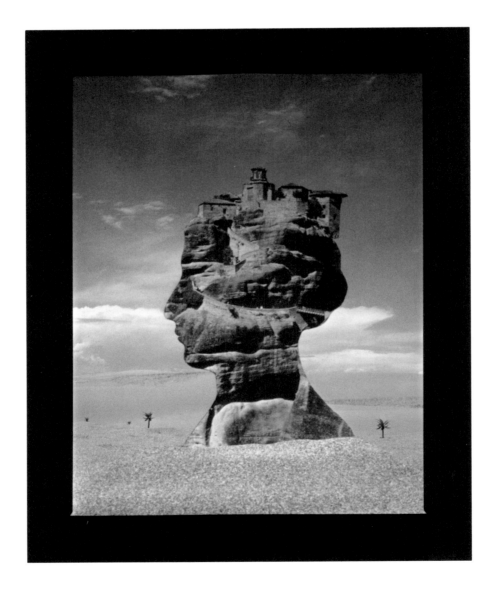

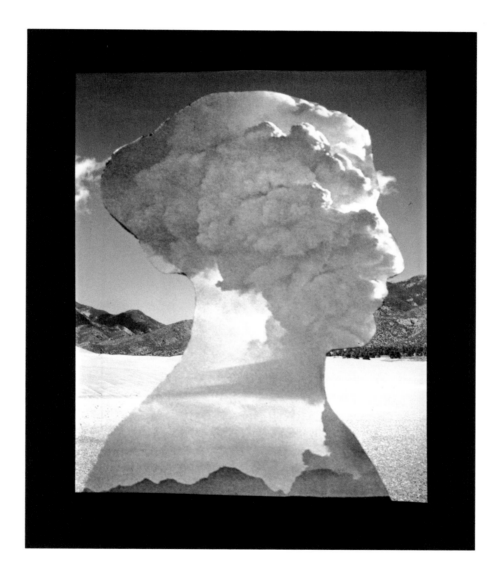

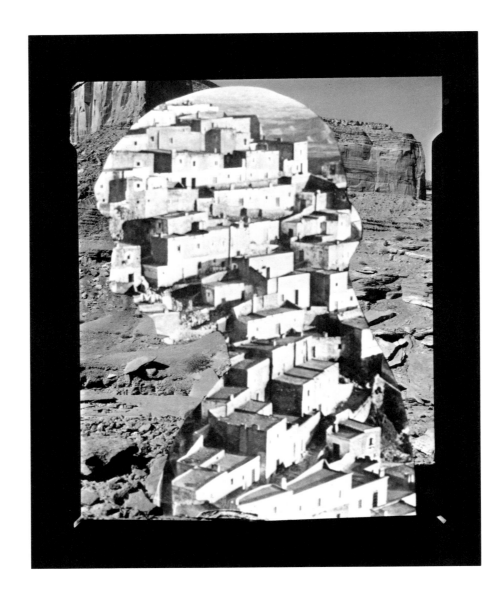

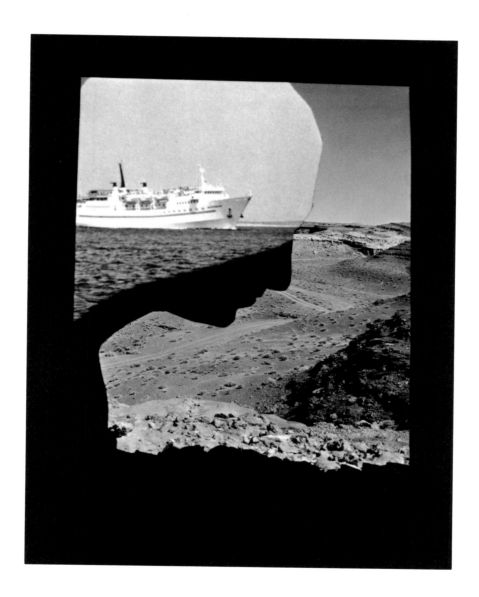

PAGE 118, PLATE 66, CAT. 58

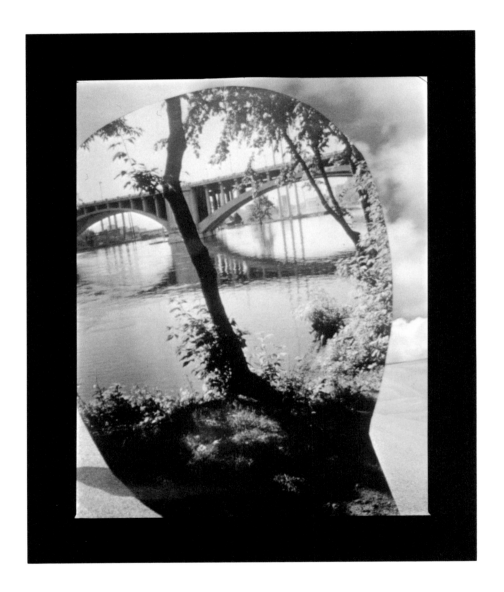

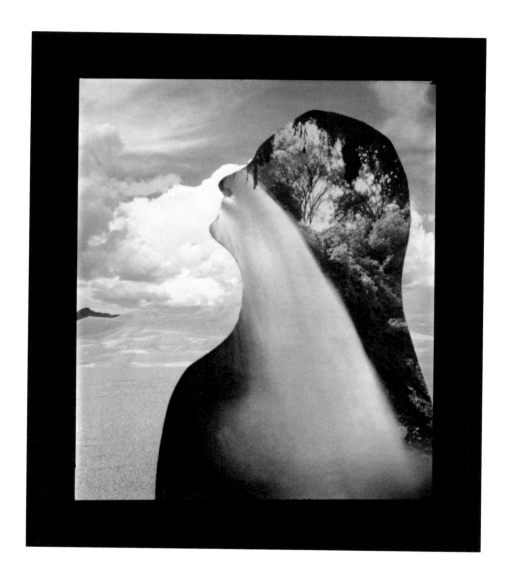

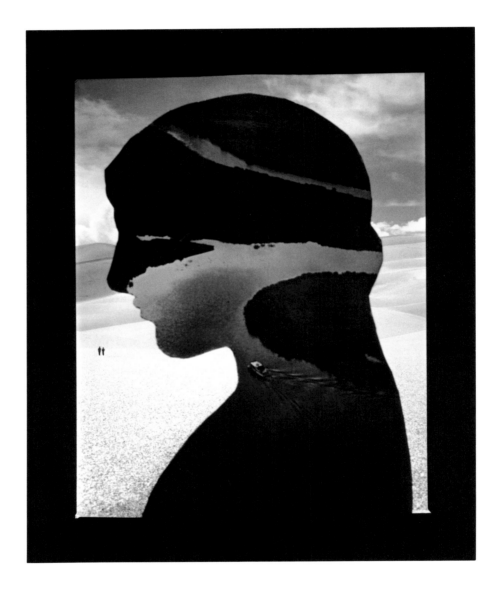

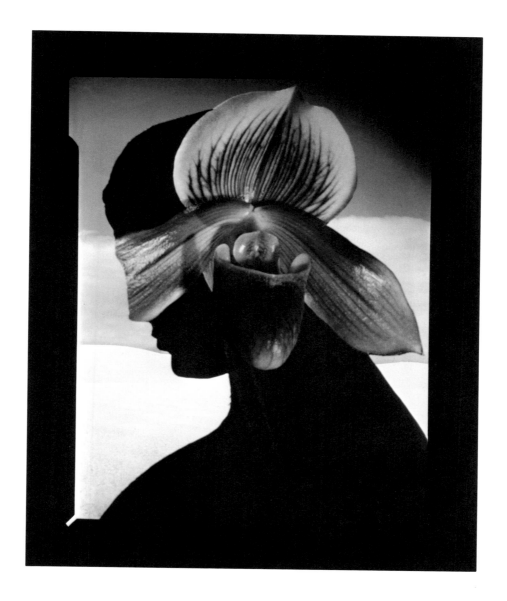

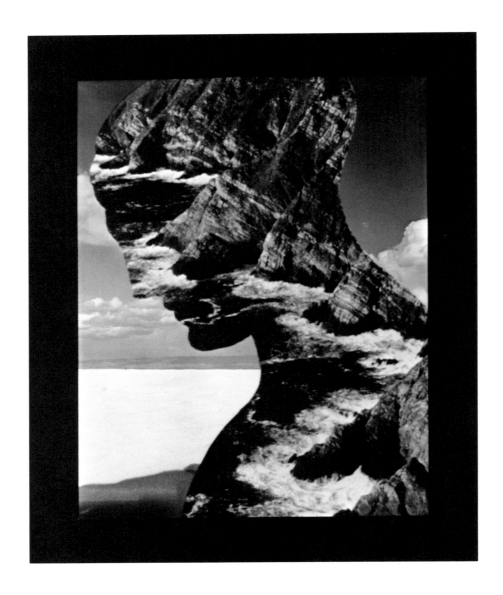

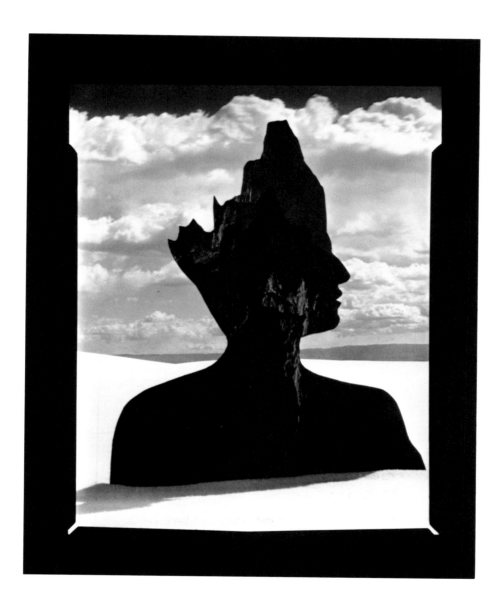

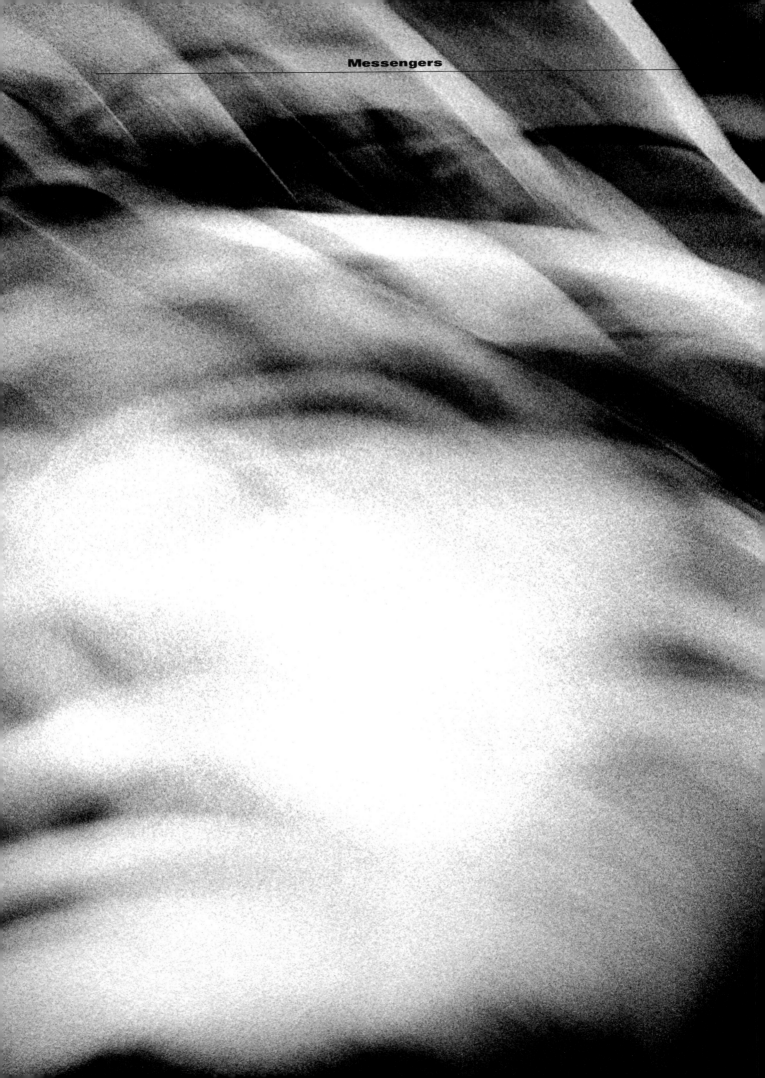

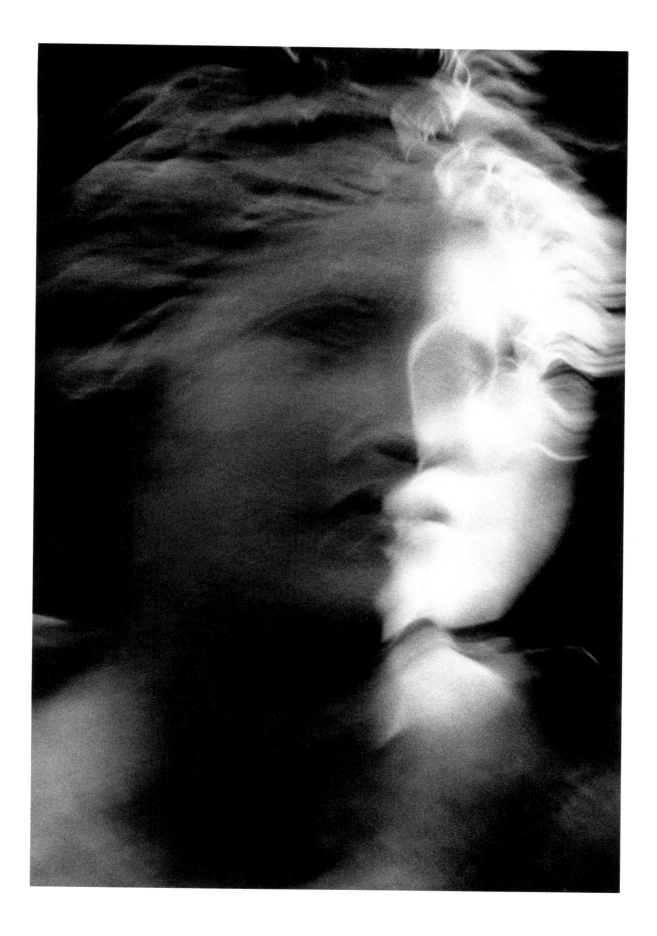

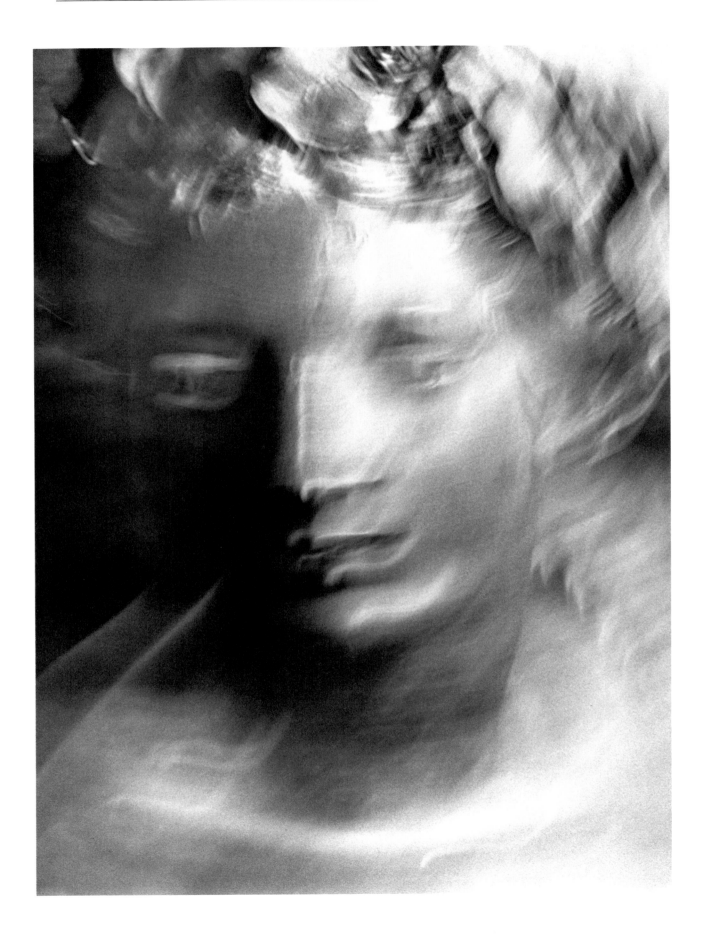

Messenger #20, France, 1989

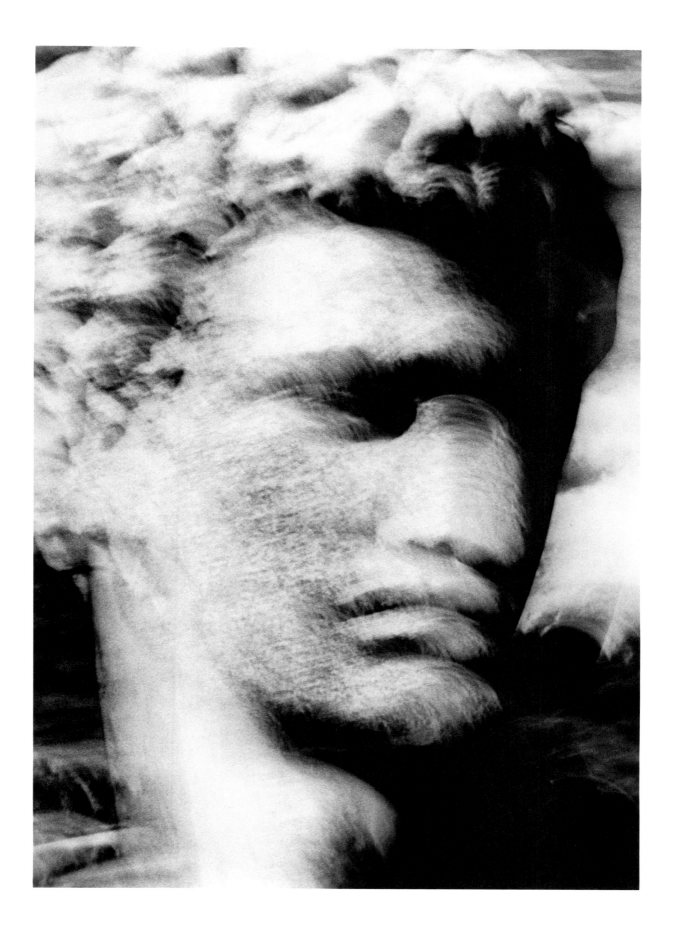

Messenger #16, Italy, 1989

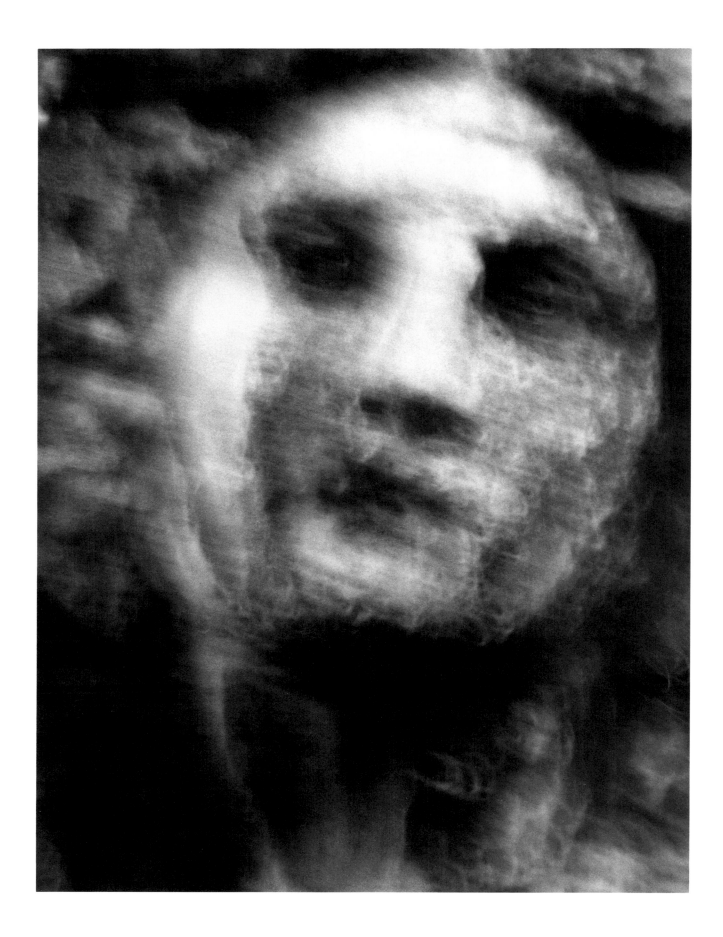

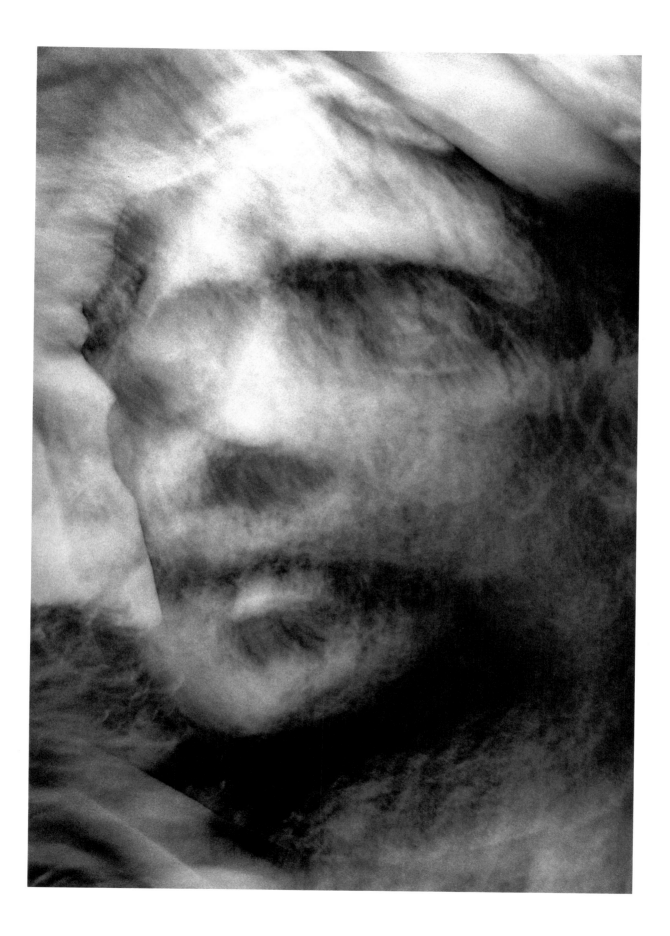

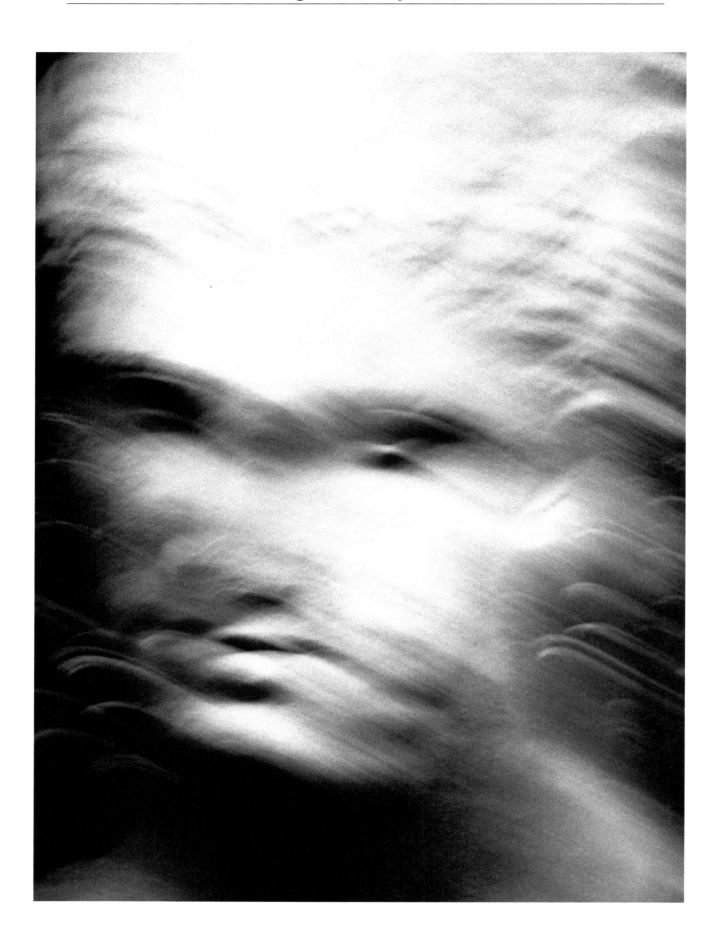

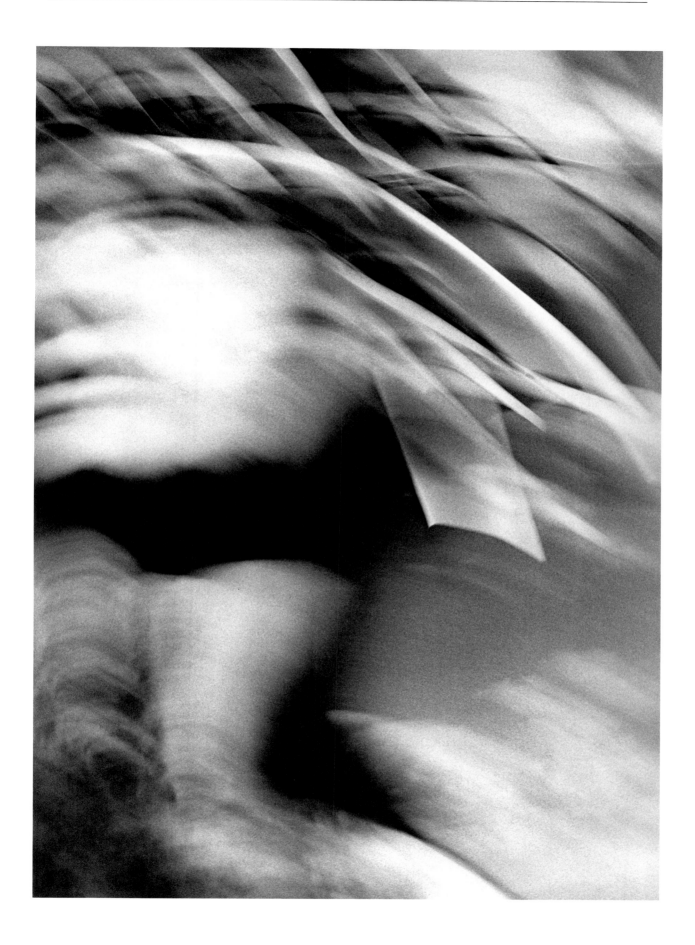

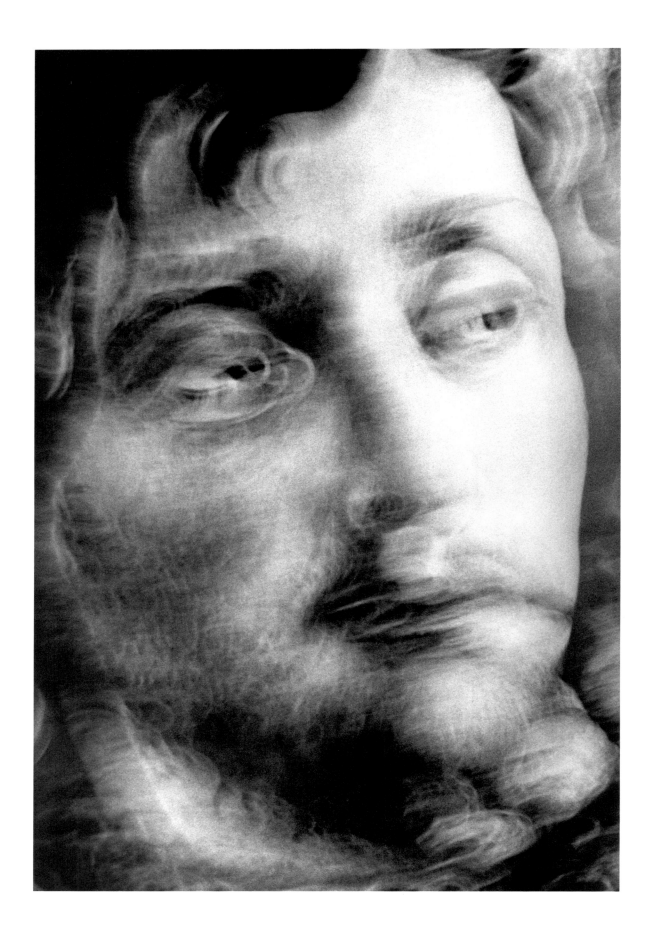

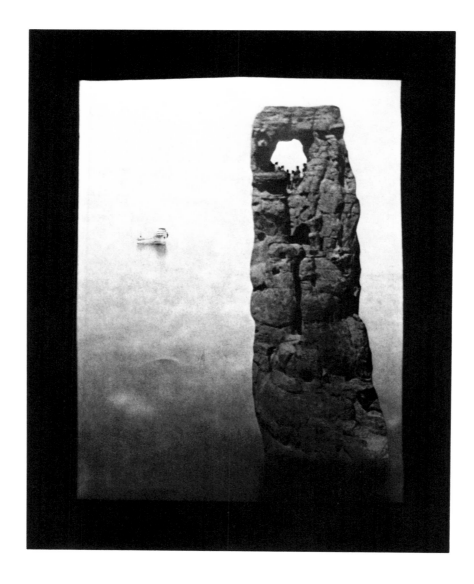

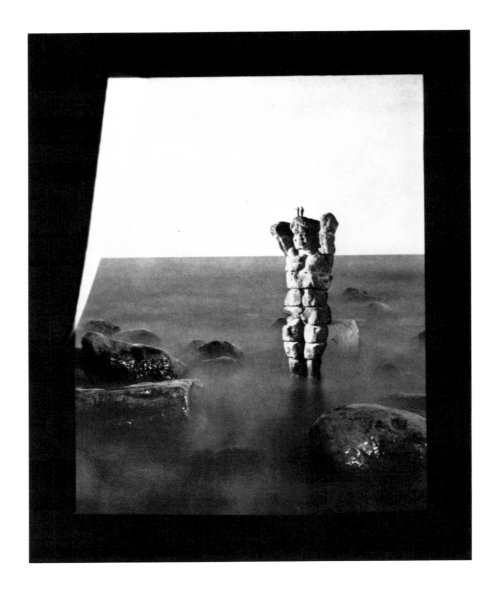

Altar, Wisconsin, 1991

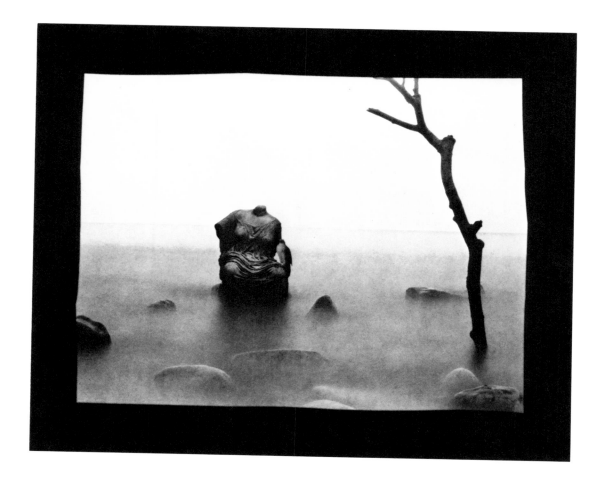

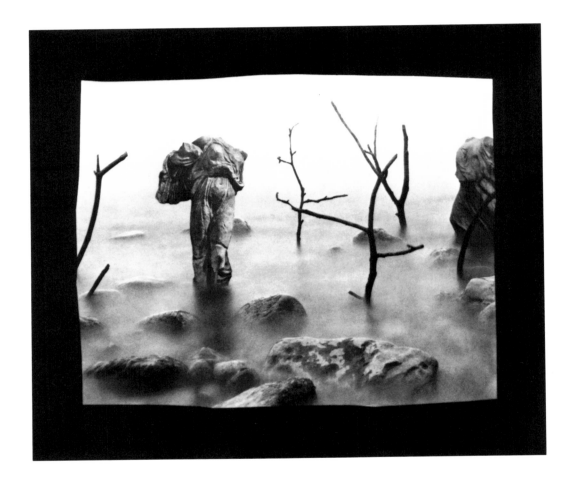

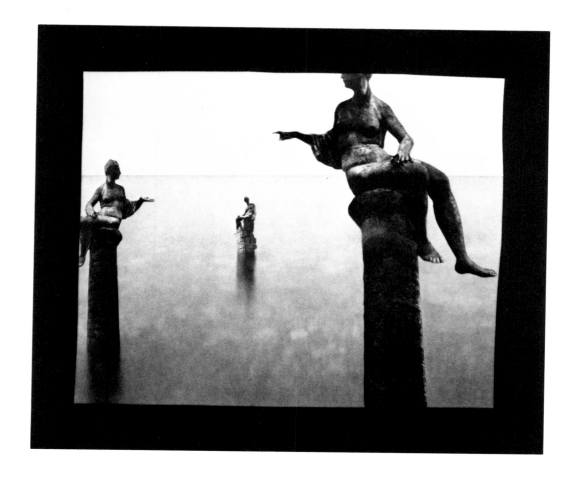

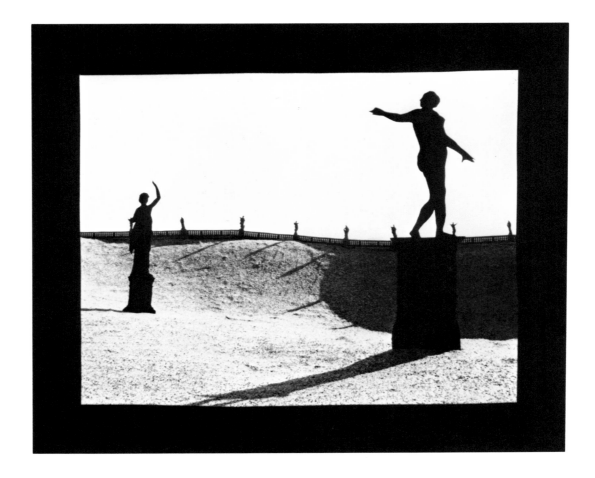

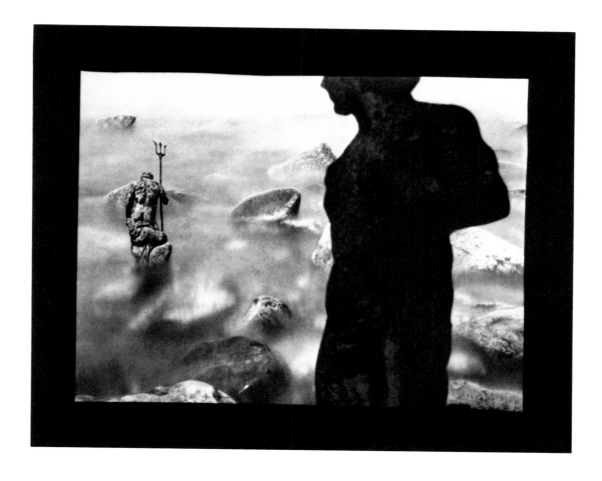

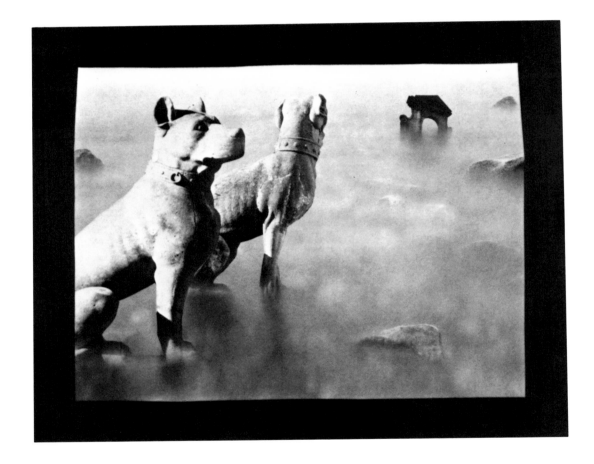

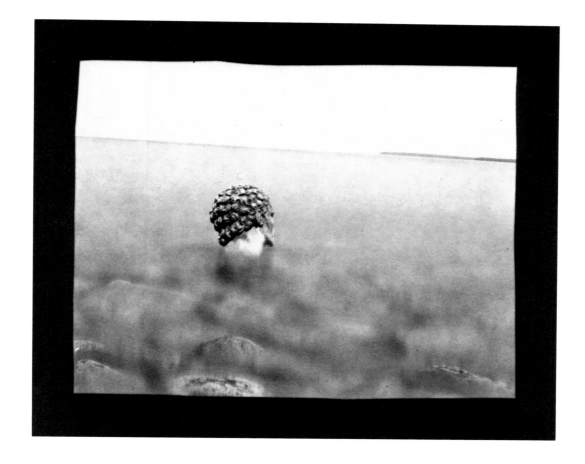

Catalogue of the Exhibition

Expeditions

Toned silver gelatin prints, approximately
4-by-5 inches, in editions of 25.

1. Airplane Disaster, Illinois, 1976 (Pl. 3)
2. Fish, Illinois, 1976 (Pl. 4)
3. Horses, Illinois, 1976 (Pl. 6)
4. Pyramid, California, 1976 (Pl. 1)
5. Pyramid and Palms, California, 1976 (Pl. 2)
6. Running Horse, Illinois, 1976 (Pl. 5)
7. Arches, California, 1977 (Pl. 7)
8. Building and Palms, California, 1977 (Pl. 8)
9. Olive, Mexico, 1977 (Pl. 9)
10. Face at Tulum, Mexico, 1978 (Pl. 10)
11. The Leap, California, 1978 (Pl. 13)
12. Liberty Head, Illinois, 1978 (Pl. 12)
13. Ozymandias, Illinois, 1978 (Pl. 14)
14. Paper Pillar, Illinois, 1978 (Pl. 15)
15. Silver Shoe, Mexico, 1978 (Pl. 11)
16. Glider, Illinois, 1979 (Pl. 16)
17. Head with Ladders, Illinois, 1979 (Pl. 17)
18. Head with Plane, Illinois, 1979 (Pl. 19)
19. Sphinx, Illinois, 1979 (Pl. 20)
20. Tower, Illinois, 1979 (Pl. 18)
21. Blimp, Mexico, 1980 (Pl. 22)
22. Brigitte, Illinois, 1980 (Pl. 21)
23. Flying Man (Version 1), Mexico, 1981 (Pl. 23)
24. Paper Palms, California, 1981 (Pl. 24)
25. Photographer, California, 1981 (Frontispiece)
26. Cones, California, 1982 (Pl. 25)
27. Cylinders, California, 1982 (Pl. 26)
28. Geometric Lady, California, 1982 (Pl. 29)

29. Pyramid and Plane, California, 1982 (Pl. 28)
30. Rider, California, 1982 (Pl. 27)
31. Columns at Monument Valley, Arizona, 1984 (Pl. 30)
32. Fallen Face, Arizona, 1984 (Pl. 32)
33. Ray at Monument Valley, Arizona, 1984 (Pl. 33)
34. Stoneface, Utah, 1984 (Pl. 31)

Door

Toned silver gelatin prints, approximately
4-by-5 inches, in editions of 25.

35. Monolith, California, 1981 (Pl. 34)
36. 2-Face, California, 1982 (Pl. 35)
37. Arc de Triomphe, Wisconsin, 1983 (Pl. 36)
38. Buildings in Fog, Wisconsin, 1983 (Pl. 37)
39. Chair Over Point, Wisconsin, 1983 (Pl. 38)
40. Dot-Lady, Wisconsin, 1983 (Pl. 43)
41. Falling Pillars, Wisconsin, 1983 (Pl. 40)
42. Flying Dot-Man, Wisconsin, 1983 (Pl. 41)
43. Head and Boat, Wisconsin, 1983 (Pl. 39)
44. Levitating Man, Wisconsin, 1983 (Pl. 44)
45. Primal Man, Wisconsin, 1983 (Pl. 42)
46. Rising Face, Wisconsin, 1983 (Pl. 45)

Prima Materia

Toned silver gelatin prints, approximately
4-by-5 inches, in editions of 25.

47. Arc, Italy, 1985 (Pl. 49)
48. Bridge, Italy, 1985 (Pl. 51)
49. Checkerboard and Chapel, Italy, 1985 (Pl. 47)
50. Pines at Baratti, Italy, 1985 (Pl. 46)
51. Puzzle, Italy, 1985 (Pl. 48)
52. Pyramid, Italy, 1985 (Pl. 50)

53. Two Faces Are a Vase, Italy, 1985 (Pl. 52)

54. Boxers, New Mexico, 1986 (Pl. 54)

55. Conquistador, New Mexico, 1986 (Pl. 53)

56. Earthling, New Mexico, 1987 (Pl. 56)

57. Venus, South Carolina, 1987 (Pl. 55)

Views from the Shoreline

Toned silver gelatin prints, approximately
5-by-4 inches, in editions of 25; and 40-by-30
inches and 5-by-4 feet, in editions of 12.

58. A Face Is a Place, Colorado, 1986 (Pl. 66)

59. Harlequin Head, Colorado, 1986 (Pl. 57)

60. Hilltown, Arizona, 1986 (Pl. 64)

61. Homo Sum (Venice), Colorado, 1986 (Pl. 59)

62. Leda, Colorado, 1986 (Pl. 61)

63. Nepenthe, Colorado, 1986 (Pl. 68)

64. Screwhead, Colorado, 1986 (Pl. 60)

65. Thunderhead, Colorado, 1986 (Pl. 63)

66. Turrita Mater, Colorado, 1986 (Pl. 62)

67. Waterfall, Colorado, 1986 (Pl. 67)

68. White Ship, Utah, 1986 (Pl. 65)

69. Zig-Zag Man, Utah, 1986 (Pl. 58)

70. Fata Morgana, New Mexico, 1987 (Pl. 70)

71. Flora Bella, New Mexico, 1987 (Pl. 69)

72. Niobe, New Mexico, 1987 (Pl. 71)

Messengers

Toned silver gelatin prints, approximately
42-by-30 inches and 5-by-4 feet, in editions of 15.

73. Messenger #20, France, 1989 (Pl. 73)

74. Messenger #12, Italy, 1989 (Pl. 75)

75. Messenger #14, Italy, 1989 (Pl. 76)

76. Messenger #16, Italy, 1989 (Pl. 74)

77. Messenger #2, France, 1990 (Pl. 78)

78. Messenger #4, France, 1990 (Pl. 72)

79. Messenger #10, France, 1990 (Pl. 80)

80. Messenger #17, Italy, 1990 (Pl. 79)

81. Messenger #1, Pennsylvania, 1990 (Pl. 77)

Songs of the Sea

Toned silver gelatin prints, approximately
4-by-5 inches, in editions of 25.

82. Altar, Wisconsin, 1991 (Pl. 84)

83. Duet, Wisconsin, 1991 (Pl. 81)

84. Echo, Wisconsin, 1991 (Pl. 82)

85. Gate, Wisconsin, 1991 (Pl. 90)

86. Guardian, Wisconsin, 1991 (Pl. 89)

87. Headless, Wisconsin, 1991 (Pl. 85)

88. Parable, Wisconsin, 1991 (Pl. 86)

89. Rock Tower, Wisconsin, 1991 (Pl. 83)

90. September 4th, Wisconsin, 1991 (Pl. 88)

91. Trio, Wisconsin, 1991 (Pl. 87)

92. Limbo Man, Wisconsin, 1992 (Pl. 91)

All photographs presented courtesy of the artist.

Documentation

By Stephanie J. Graff

Biography

Born: 1943, New York
Resides: Philadelphia, and Moab, Utah

Education

1961—63 FA (Dance) Columbia College,
Columbia, Missouri
1966—70 BFA (Painting) Southern Illinois University,
Carbondale
1971—73 BA (Photography) Columbia College Chicago
1974—76 MFA (Photography) The School of The Art
Institute of Chicago

Professional Experience

1964—65 Sybil Shearer Dance Company, Northbrook,
Illinois (Dancer)
1974—83 Columbia College Chicago
1978 Chicago Sun-Times (Staff Photographer)
1983—89 University of Colorado, Denver
1989 La Napoule Art Foundation, La Napoule,
France (Residency)

Awards and Grants

1976 John Quincy Adams Fellowship, The School of
The Art Institute of Chicago
1979 National Endowment for the Humanities
Fellowship Grant, Summer Seminar, Paris
1980 Illinois Arts Council Project Completion Grant
1982 Faculty Development Grant, Columbia
College Chicago
1982 National Endowment for the Arts Visual Artist
Fellowship
1986 First Bank of St. Paul, Individual Photography Grant

1987 Research and Creative Endeavor Award, University
of Colorado, Denver
1987 Honorary Professor of Photography, East Texas
State University, Department of Journalism and
Graphic Arts
1988 National Endowment for the Arts Visual Artist
Fellowship

Exhibitions
One-Person Exhibitions

1974
Carbondale, Illinois, Southern Illinois University

1975
Denver, Metropolitan State College
Los Angeles, University of California, Los Angeles,
Photography Department

1979
Las Vegas, University of Nevada, "Photographic
Fantasies"

1980
Chicago, Alan Frumkin Gallery Photographs Inc.,
"Expeditions"
Chicago, Randolph Street Gallery, "Expeditions"
Richmond, Indiana, Earlham College

1981
Buffalo, New York, C.E.P.A. Gallery
Chicago, The Art Institute of Chicago

1982
Chicago, Columbia College, The Chicago Center for
Contemporary Photography
Springfield, Illinois, Illinois State Museum

1983
New York, Marcuse Pfeifer Gallery, "Imaginary
Landscapes"

1984
Washington, D.C., Jones Troyer Gallery, "Expeditions
1976–1984"

1985
Minneapolis, Jon Oulman Gallery, "Expeditions
1976–1984"
Ruston, Louisiana, Louisiana Tech University, E.J.
Bellocq Gallery, "Expeditions"

1987
Lakeville, Connecticut, The Hotchkiss School, "Ruth
Thorne-Thomsen: Photographs from Three Series"
Minneapolis, First Bank of St. Paul Gallery, "Views from
the Shoreline: Photographs by Ruth Thorne-Thomsen"
Minneapolis, Jon Oulman Gallery, "Views from the
Shoreline"
Riverside, California, University of California, California
Museum of Photography, "Ruth Thorne-Thomsen:
Photographs from Three Series"
Tarragona, Spain, Forum Galería, "Expeditions"
Washington, D.C., Jones Troyer Gallery

1988
Austin, Texas, Trans Avant Garde Gallery
Barcelona, Museu d'Art de Sabadell
Denver, Robischon Gallery
Palermo, Italy, Novecentro Gallerie
Paris, Urbi et Orbi Galerie
Philadelphia, University of the Arts, Sol Mednick Gallery

1989
Framingham, Massachusetts, Danforth Museum of Art,
"Photographs: Ruth Thorne-Thomsen" (exh. cat.)
St. Malo, France, Halle-aux-Blés, "La Nouvelle
Photographie Ancienne"
San Francisco, Robert Koch Gallery, "Ruth
Thorne-Thomsen"

1990
Chicago, Ehlers Caudill Gallery

1991
Houston, Benteler-Morgan Galleries, "Ruth
Thorne-Thomsen"
New York, Laurence Miller Gallery, "Messengers"
Salt Lake City, University of Utah, Utah Museum of Fine
Arts, "Ruth Thorne-Thomsen: Photographer"

1992
Chicago, Ehlers Caudill Gallery, "Messengers"
Denver, Robischon Gallery, "Songs of the Sea"
Los Angeles, Jan Kesner Gallery, "Songs of the Sea"
Philadelphia, Jessica Berwind Gallery, "Photographs"

Group Exhibitions
1973
Chicago, Exchange National Bank, "Children:
1843–1973"

1974
Chicago, The Art Institute of Chicago, "Chicago and
Vicinity Show"
Chicago, N.A.M.E. Gallery
Chicago, The Darkroom, "Exposure 1974"

1975
Chicago, Columbia College Galleries, "Public Art
Workshop Show and Auction"
Evanston, Illinois, Northwestern University, Dittmar
Memorial Gallery, "Women's Invitational Photographic
Exhibit"

1976
Chicago, The Art Institute of Chicago, "Fellowship Show"
Chicago, John Doyle Gallery, "Ten Chicago Artists"

1977
Chicago, The Art Institute of Chicago, "Recent
Acquisitions"
Chicago, Museum of Contemporary Art, "The
Photographer and the City" (exh. cat.)
Chicago, Rizzoli International Gallery

1978
Chicago, Columbia College, The Chicago Center for
Contemporary Photography, "Wall to Wall: An
Exhibition of Large-Scale Photographs"

1979
Breckenridge, Colorado, Colorado Mountain College
Gallery, "Pinhole Camera Work"
Lexington, Kentucky, University of Kentucky, Barnhart
Gallery, "The Big Show, Large-Scale Contemporary
Photographs"
Minneapolis, Women's Art Registry of Minnesota,
"Photography Invitational: 6 Artists"
Santa Barbara, California, Santa Barbara Museum of
Art, "Attitudes: Photography in the 70's" (exh. cat.)

1980

Cincinnati, Ohio, The Contemporary Arts Center, "Chicago/Chicago — An Exhibition of Recent Sculpture, Painting, Drawing, Photography and Video" (exh. cat.)

La Jolla, California, La Jolla Museum of Contemporary Art, "Landscape Images: Recent Photographs by Linda Conner, Judy Fishkin, and Ruth Thorne-Thomsen" (exh. cat.)

Los Angeles, Center for Photographic Studies, "ORD 2 LAX"

Philadelphia, Jeffrey Fuller Fine Art, "Sign and Symbol — An Exhibition of Painting and Photographs"

Rochester, New York, Visual Studies Workshop, "The Image Considered"

San Francisco, San Francisco Museum of Modern Art, "Crosscurrents: Additions to the Permanent Collection of Photography During 1979"

Springfield, Illinois, Illinois State Museum, "Illinois Photographers '80"

Tuscon, Arizona, University of Arizona, Light Song Gallery, "Diana Schoenfeld and Ruth Thorne-Thomsen"

1981

Chicago, Columbia College, The Chicago Center for Contemporary Photography, "New Acquisitions to the Permanent Collection"

Evanston, Illinois, Northwestern University, Dittmar Memorial Gallery, "Contemporary Pulse 80's Vision from Chicago"

Laguna Beach, California, BC Space, "1981 Photography Auction and Exhibition"

Minneapolis, Walker Art Center, "Midwest Photography" (exh. cat.)

Montreal, Saidye Bronfman Centre Museum, "Visions from Chicago"

Philadelphia, Jeffrey Fuller Fine Arts, "Contemporary Photography"

Philadelphia, Tyler and Penrose Galleries, "Imaginary Civilizations"

Riverside, California, University of California, California Museum of Photography, "Acquisitions 1981"

San Francisco, San Francisco Museum of Modern Art, "Photographic Reflections of the World of Illusion and Fantasy"

Santa Barbara, California, Santa Barbara Museum of Art, "Photographs from the Permanent Collection"

1982

Champaign, Illinois, University of Illinois, "Altered States"

Chicago, The Art Institute of Chicago, "Photographs from the Permanent Collection"

New York, Robert Friedus Gallery, "Chicago Group Show"

Richmond, Virginia, The Institute of Contemporary Art of The Virginia Museum, "The Pinhole Image — Eleven Photographers" (exh. cat.)

1983

Birmingham, Michigan, Pierce Street Gallery, "New Trends"

Boston, Alchemic Gallery, "Timed and Spaced"

Chicago, Edwynn Houk Gallery, "The City"

Chicago, Museum of Contemporary Art, "Work from the Permanent Collection"

Denver, University of Colorado, Emmanuel Gallery, "UCD Faculty Show"

Denver, Grant Street Art Center, "Photography Invitational"

New York, Just Above Midtown/Downtown, "Photography: New Approaches"

Philadelphia, Temple University, Tyler School of Art, "Handmade Cameras — Contemporary Images"

Santa Fe, Santa Fe Armory, "Film and Photo Expo"

1984

Arvada, Colorado, Arvada Center for the Arts, "American Photography Today — 1984"

Chicago, Museum of Contemporary Art, "Alternative Spaces — A History in Chicago" (exh. cat.)

Denver, University of Colorado, Emmanuel Gallery, "Small Works Benefit Art Sale"

Minneapolis, Jon Oulman Gallery, "Black and White Photography: Tradition and Response"

New York, New York Historical Society, "Visions of Liberty"

Philadelphia, Matthew Hamilton Gallery, "Landscape"

Port Washington, New York, Port Washington Library, "Constructed Images: Neil Maurer and Ruth Thorne-Thomsen"

Rochester, New York, Visual Studies Workshop, "Landscape Starts Here — An Exhibition of Photographs"

St. Louis, First Street Forum, "Cityscapes — 20th Century Urban Images from the Hallmark Photographic Collection"

St. Paul, Minnesota, Film in the Cities, "Landscapes: Illusion and Reality, Photographs by Ruth Thorne-Thomsen and Wayne Gudmundsen"

1985

Albuquerque, New Mexico, University of New Mexico, North Gallery, "Thorne-Thomsen/Frith"

Charlotte, North Carolina, The Light Factory, "Ruth Thorne-Thomsen/Robert Stewart"

Cincinnati, Ohio, Images Gallery, "The Visionary Pinhole" (exh. cat)

Commerce, Texas, East Texas State University, "Ten Contemporary Photographers"

Denver, Auraria Library Gallery, "Women by Women"

Houston, The Museum of Fine Arts, "Recent Accessions"

New York, International Center of Photography, "Photographs from the Sam Wagstaff Collection at The J. Paul Getty Museum"

New York, International Center of Photography/Midtown, "City Light"

Oceanville, New Jersey, The Noyes Museum, "An Inside Place" (exh. cat.)

San Diego, California, Museum of Photographic Arts, "Faces: Photographs from the Hallmark Collection"

San Francisco, San Francisco Museum of Modern Art, "Extending the Perimeters of Twentieth Century Photography"

San Francisco, San Francisco Museum of Modern Art, "Sign of the Times — Some Recurring Motifs in Twentieth-Century Photography" (exh. cat.)

1986

Arvada, Colorado, Arvada Center for the Arts and Humanities, "Prisoners of Conscience" (exh. cat.)

Chicago, Hyde Park Art Center, "Hyde Park Pix"

Denver, Grant Street Art Center, "Seven Against the Wall"

Denver, Robischon Gallery, "New Gallery Artists"

New York, Barney's, "The Embellishment of the Statue of Liberty"

New York, Park Avenue Atrium, "Mementos — Art and Artifacts"

Stanford, Connecticut, Whitney Museum of American Art, Fairfield County, "Photographic Fictions" (exh. cat.)

West Nyack, New York, Rockland Center for the Arts, "A Matter of Scale"

1987

Alexandria, Virginia, The Athenaeum, "Photography: Process"

Baltimore, Baltimore Museum of Art, "Arrangements for the Camera: A View of Contemporary Photography"

Chicago, The Art Institute of Chicago, "Reordered and Revealed: Photographic Work by Joyce Neimanas, Lorie Novak, Esther Parada and Ruth Thorne-Thomsen"

Guadalajara, Spain, "Semana Internacional de la Fotografía" (exh. cat.)

Los Angeles, Jan Kesner Gallery, "Inaugural Exhibition: Jo Ann Callis, John Divola, Ruth Thorne-Thomsen"

Los Angeles, Los Angeles County Museum of Art, "Photography and Art: Interactions Since 1946" (traveled to Fort Lauderdale, Florida, The Museum of Art, 1988; Flushing, New York, The Queens Museum of Art, 1988) (exh. cat.)

New York, Alternative Museum, "Poetic Injury: The Surrealist Legacy in Post-Modern Photography" (exh. cat.)

Santa Fe, Museum of New Mexico, The Museum of Fine Arts, "Poetics of Space: Contemporary Photographic Works"

1988

Barcelona, Metronom, "Estampes Apocrifes" (exh. cat.)

Madrid, Círculo de Bellas Artes, "Foco" (exh. cat.)

Minneapolis, Jon Oulman Gallery, "Beyond the Blue Horizon: Landscapes by Four Contemporary Photographers"

Rockford, Illinois, Clark Arts Center Gallery, "Contemporary American Photography" (exh. cat.)

San Francisco, San Francisco Camerawork, "1988 S.F. Camerawork Auction" (exh. cat.)

1989

Bronxville, New York, Sarah Lawrence College, "Still Surreal: Contemporary Photographers in the Surrealist Tradition"

Chicago, ARC Gallery, "The Art of the Pinhole: Photographs by Ruth Thorne-Thomsen, Duncan Mitchell, Bruce Berman"

Chicago, Ehlers Caudill Gallery, "Decisive Monuments"

Chicago, Randolph Street Gallery (exh. cat.)

Denver, Robischon Gallery, "Masterworks"

Freiburg, West Germany, Galerie Kunst

Houston, Houston Center for Photography, Exhibition and Auction (exh. cat.)

Los Angeles, Jan Turner Gallery, "Photomontage/Photocollage: The Changing Picture, 1920—1989"

New York, Joseph E. Seagram Collection, "Shadows and Silhouettes: Chiaroscuro in Photographic Images"

New York, The Metropolitan Museum of Art, "Invention and Continuity in Contemporary Photographs"

Ogden, Utah, Weber State College, Collett Art Gallery, "Big Photographs"

Paris, Centre Culturel, "Technique Ancienne dans la Photographie Contemporaine"

Paris, Palais de Tokyo, "Fonds National d'Art Contemporain Acquisitions 1988"

Santa Barbara, California, Santa Barbara Museum of Art, "Attitudes Revisited"

San Francisco, The Friends of Photography, "Nature and Culture: Conflict and Reconciliation in Recent Photography"

San Francisco, San Francisco Camerawork, Exhibition and Auction (exh. cat.)

Washington, D.C., The National Museum of American Art, "Photography of Invention: American Pictures of the 1980's" (traveled to Chicago, Museum of Contemporary Art, 1989–90; Minneapolis, Walker Art Center, 1990) (exh. cat.)

1990

Arles, France, Musée d'Arles, Espace Van Gogh, "Fixe sur l'éternité"

Chicago, Ehlers Caudill Gallery, "Ralph Eugene Meatyard and Ruth Thorne-Thomsen"

Chicago, Columbia College Chicago, The Museum of Contemporary Photography, "Thirty Years After the Americans, 1959–1990"

Chicago, "Photography! An Exhibition and Auction to Benefit the New Art Examiner"

Denver, Robischon Gallery, "Big Pictures"

Gainesville, Florida, University of Florida, University Gallery, "Seductive Deceptions: The Theatrical Image"

Honolulu, The University of Hawaii Art Gallery, "Symbol and Surrogate: The Picture Within" (exh. cat.)

London, The Special Photographers Company, "Selected Works"

Minneapolis, Jon Oulman Gallery, "To My Valentine — Erotic Images in Art"

Philadelphia, The Print Club, "Natural Magic: Pinhole Photographers"

1991

Chicago, The Art Institute of Chicago, "The Intuitive Eye: Photographs from the Collection of David C. and Sarajean Ruttenberg"

Amsterdam, The Fourth Wall, "The Fourth Wall: Photography as Theater" (exh. cat.)

Philadelphia, The Institute of Contemporary Art, "The Photo Review Benefit Auction"

Rockford, Illinois, Rockford College, "Women Viewing Women"

Santa Fe, Museum of New Mexico, Museum of Fine Arts, "To Collect the Art of Women: The Jane Reese Williams Collection"

Sweetbriar, Virginia, Randolph Macon Women's College, Maier Museum of Art, "The 80th Annual Exhibition: Focus on Photography 1980–1990"

Washington, D.C., Kathleen Ewing Gallery, "The Horse, Photographic Images: 1839 to Present" (exh. cat.)

1992

Houston, Houston Center for Photography, "Fantastic Voyages"

Selected References

Abbe Martin, Mary. "Critics' Choice." *Minneapolis Star and Tribune*, Sept. 11, 1987, p. 13.

_____. "Gallery Shows Put a Frame Around History." *Minneapolis Star and Tribune*, Apr. 30, 1992, p. 1E.

_____. "Three Shows Exhibit Photography." *Minneapolis Star and Tribune*, Nov. 3, 1985, p. 3G.

Allen, Jane Addams. "Looking at the World through a Pinhole." *Washington Times*, Dec. 7, 1985, p. B2.

_____. "The Pictures That Steal the Show." *Insight on the News*, June 12, 1989, pp. 60–61.

"Altered Subjects." *Quiver 1980* 2, 1 (1980), pp. 8–9.

"The Avant Garde." Helicon Nine — The Journal of Women's Arts and Letters 20 (1989), pp. 24–27.

Arvada, Colorado, Arvada Center for the Arts. *Prisoners of Conscience.* Text by Michael P. Crane. Arvada, 1986.

Baldwin, Gordon. *Looking at Photographs: A Guide to Technical Terms.* Malibu, California: J. Paul Getty Museum in association with British Museum Press, 1991.

Ballerine, Luigi, and Charles Traub. *Italy Observed in Photographs and Literature.* New York: Rizzoli International Publishers, 1988.

Barcelona, Metronom. *Estampes Apocrifes.* Text by Chantal Grande and Cristina Zelich. Barcelona, 1988.

Baruch, Gail. "Keyhole to the Imagination: Exhibit Artists Stretch Limits of Photography." *Rockford Register Star*, Jan. 22, 1988.

Bonetti, David. "Postcards from a Dream." *San Francisco Examiner*, Nov. 8, 1989, p. D4.

Borhan, Pierre. "Dans le Jamais Déjà-Vu." *Clichés* (Paris) 34 (Mar. 1987), pp. 40–47.

Chadwick, Susan. "Introductions '91 Hones in on Surrealism." *The Houston Post*, July 23, 1991, p. 2.

Clarke, Orville O. "Ruth Thorne-Thomsen." *Art Scene* 11 (July–Aug. 1992), pp. 14–15.

Clurman, Irene. "Eye on Art." *Rocky Mountain News*, Jan. 10, 1986, p. 27.

———. "Faces Tell a Story of Pride and Poverty." *Rocky Mountain News*, Sept. 10, 1985, p. 46.

Cohen, Alan. "The View Finders." *TWA Ambassador Magazine*, July 1979, pp. 40–44.

Coleman, A.D. "The Image in Question—Further Notes on the Directorial Mode." *Center Quarterly* 9, 4 (Summer 1988), pp. 4–9.

Cook, Jno. "The Marvelous Journey—Photographs of Ruth Thorne-Thomsen." *Nit & Wit*, Mar.–Apr. 1982, pp. 42–43.

Crowder, Joan. "Changes: Attitudes Revisited." *Santa Barbara Press*, July 18, 1989.

Darkroom 5, 2 (Feb. 1983), p. 11.

Davis, Keith. "Hallmark Collection." *Center Quarterly* 8, 1 (1986), p. 10.

———. "My Favorite Pictures." *Ozark Magazine* 15, 5 (Oct. 1986), p. 41.

"Discoveries." *Photography Year 1980*. New York: Time/Life (1980), pp. 192–99.

Donohue, Victoria. "Ruth Thorne-Thomsen at the University of the Arts." *Philadelphia Inquirer*, Sept. 9, 1988.

Edwards, Owen. "Songs and Arrows." *American Photographer* 9, 5 (Nov. 1982), pp. 26–28.

———. "Tripping the Light Fantastic." *American Photographer* 12, 3 (Mar. 1984), pp. 22–23.

Elliott, David. "Chicago Can Love Its Own Art." *ARTnews* 80, 4 (Apr. 1981), pp. 134–36.

Engstrom, John. "Critic's Choice." *The Boston Globe*, Feb. 19, 1989, p. 49.

Ewing, William A. *Flora Photographica*. New York: Simon & Schuster Publishers, 1991.

Fontcuberta, Joan. "Countervisions: Zeus' Eye Against Zeiss' Eye." *European Photography* 7, 4 (Dec. 1987), pp. 14–30.

———. "Una Revision de los Origenes." *Photo Vision* 15 (Nov. 1984), pp. 16–17, 32–34, 52–53.

Foerstner, Abigail. "Souvenirs of Surreal Journeys." *Chicago Tribune*, Apr. 8, 1988, p. 87.

———. "Thorne-Thomsen Sends Messengers of Interior Worlds." *Chicago Tribune*, Jan. 31, 1992, p. 71.

Goldberg, Vicki. "Take Two Media, Mix Well." *The New York Times Book Review*, Dec. 6, 1987, p. 21.

Gray, Alice. "Ruth Thorne-Thomsen." *ARTnews* 91, 3 (Mar. 1992) p. 131.

Grundberg, Andy. "Tradition Reasserts Itself in Photography." *The New York Times*, Sept. 11, 1983, pp. 39, 45.

Hagen, Charles. "Ruth Thorne-Thomsen at Marcuse Pfeifer Gallery." *Artforum* 26, 6 (Feb. 1988), p. 141.

———. "Visions of Liberty." *Artforum* 23, 2 (Oct. 1984), pp. 88–89.

Honolulu, Hawaii, The University of Hawaii Art Gallery. *Symbol and Surrogate: The Picture Within.* Text by Diana Schoenfeld. Honolulu, 1989.

Howell-Koehler, Nancy. *The Creative Camera.* Worcester, Massachusetts: Davis Publications Inc., 1989.

ICP Encyclopedia of Photography. New York: Crown Publishers, 1985, p. 339.

"Images by Woman." *Pinhole Journal* 3, 1 (Apr. 1987), p. 22.

Jarmusch, Ann. "The Nation." *ARTnews* 79, 8 (Oct. 1980), p. 81.

Johnson, Patricia C. "Variety the Hallmark of 'Introductions 1991'." *Houston Chronicle*, July 20, 1991, p. 4D.

Lau, Alberto. "Landscapes Near and Far." *Artweek* 12, 1 (Jan. 10, 1981), p. 12.

Marano, Lisbeth. "Ruth Thorne-Thomsen at Marcuse Pfeifer." *Art in America* 72, 4 (Apr. 1984), pp. 188–89.

Mohnke, Mary Sue. "Manipulated Images Send Uniquely Personal Messages." *Chicago Tribune*, Dec. 18, 1987, p. 78.

"Multiples/The Gala Effect." *Pinhole Journal* 5, 2 (Aug. 1989), pp. 18–19.

New York, Alternative Museum. *Poetic Injury :
The Surrealist Legacy in Post-Modern
Photography*. Text by Gerald Roger Denson.
New York, 1987.

Oceanville, New Jersey, The Noyes Museum. *An Inside
Place — Interior Spaces of the Mind and Eye*.
Text by Sid Sachs. Oceanville, 1985.

"Opening Exhibit Had Attitudes." *Santa Barbara News
Press*, June 30, 1989.

Osgood, Charles. "Travels with Ruth." *Chicago Tribune*,
Feb. 18, 1990, p. 34.

Pagel, David. "Balancing Act." *Los Angeles Times*, Aug.
13, 1992, p. F10.

Patin, Thomas. "Ruth Thorne-Thomsen at Robischon
Gallery." *Artspace* 12 (Fall 1988).

"Pinhole Camera Art Work at Bullocq Gallery." *Ruston
Daily Leader*, Oct. 16, 1985.

Porges, Timothy. "Chicago." *Contemporanea
International Magazine* 3, 5 (May 1990), p. 49.

Power, Mark. "Photography in Washington." *The Photo
Review* 8, 2 (Spring 1985), p. 7.

Price, Max. "Wide-Ranging Robischon Show Features
Work of Six Area Artists." *The Denver Post*,
Dec. 27, 1985.

The Print Collector's Newsletter 13, 5 (Nov.–Dec. 1982),
p. 172.

Raynor, Vivien. "Office Complex with an Eye to
Exhibits." *The New York Times*, May 18,
1986, p. 24.

Ribalta, Jorge. "Objectividad y Ficción: Reflexiones
Acerca de 19 Fotografía Construdía."
Quaderns Fundacio Caixa de Pensions 41
(Oct. 1988), pp. 18–33.

Roberts, John. "Prisoners of Conscience — An Art
Project to Salute Amnesty International on its
25th Anniversary." *Muse — The Art Newspaper
for Colorado* 43 (Aug.–Sept. 1986), pp. 1, 4.

Russell, Sharman. "The Enduring Pinhole — The Art and
Science of Lensless Imagery." *Darkroom
Photography* 8, 6 (Oct. 1986), pp. 26–32.

"Ruth Thorne-Thomsen: Photographs." *Pinhole Journal*
2, 2 (Aug. 1986), pp. 20–23.

San Francisco, San Francisco Museum of Modern Art.
*Sign of the Times — Some Recurring Motifs in
Twentieth-Century Photography*. Text by
Deborah Irmas. San Francisco, 1985.

Scully, Julia, Andy Grundberg, J. Milliard, and Carol
Squires. "Landscape: Image and Idea."
Modern Photography, 46, 9 (Sept. 1982),
pp. 73–93.

Silberman, Rob. "Black and White." *Minneapolis Star
and Tribune*, Nov. 14, 1984, pp. 1, 25.

Smith, Lauren. *The Visionary Pinhole*. Salt Lake City,
Utah: Gibbs M. Smith, Inc., 1985.

Solomon-Godeau, Abigail. "Allusive Realities: Ruth
Thorne-Thomsen's Expedition Series." *The
Print Collector's Newsletter* 15, 4 (Sept.–Oct.
1984), pp. 133–36.

Sozanski, Edward J. *The Philadelphia Inquirer*, Mar. 26,
1992, p. C5.

Stanford, Connecticut, Whitney Museum of American
Art. *Photographic Fictions*. Text by Roni
Feinstein. New York, 1984.

Stang, Melissa. "Seascapes: View from the Shoreline
by Ruth Thorne-Thomsen." *Art Paper* 7, 2
(Oct. 1987), p. 15.

Stevens, Nancy. "Gallery — Ruth Thorne-Thomsen."
American Photographer, June 1979, p. 64.

Strand, Mark. "Lost in Space." *Vogue* 11, 6 (June
1984), p. 77.

Sullivan, Constance. *Women Photographers*. New York:
Harry N. Abrams, Inc., 1991.

Thall, Larry. "2 Artists Transform the Commonplace
into the Fantastic." *Chicago Tribune*, Feb. 9,
1990, p. 81.

Thornton, Gene. "Critics' Choice." *The New York Times*,
Dec. 11, 1983, p. 83.

Thrale, C.L. "Imaginary Landscapes." *Vinyl —
A Publication of the Arts*, 1985, p. 14.

Tilendis, Robert M. "Ralph Eugene Meatyard and Ruth
Thorne-Thomsen." *Dialogue Magazine*, May–
June 1990, p. 25.

Washington, D.C., Kathleen Ewing Gallery. *The Horse:
Photographic Images, 1839 to Present*. Text by
Gerald Lang and Lee Marks. Washington,
D.C., 1991.

Washington D.C., National Museum of American Art.
*Photography of Invention: American Pictures
of the 1980's*. Text by Merry Foresta and
Joshua P. Smith. Washington, D.C.:
Smithsonian Institution in association with
The MIT Press, 1989.

Weber, Richard. "Photography Offers Credible Proof." *Artspeak* 5, 8 (Dec. 16, 1983).

Weinstein, Michael A. "Art Break." *New City*, Mar. 5, 1992, p. 17.

Wiener, Phyllis Ames. "Ruth Thorne-Thomsen." *Warm Journal*, Spring 1984, pp. 11–12.

Wise, Kelly. "The Camera Never Lies, or Does it?" *The Boston Globe*, Mar. 15, 1983, p. 75.

_____. "Creating the Mystical and Metaphorical Worlds of Fancy: Photographs by Jerry Uelsmann and Ruth Thorne-Thomsen." *The Boston Globe*, Mar. 23, 1989, p. 88.

Woodward, Richard B. "Photography and Art: Queens Museum." *ARTnews* 87, 9 (Sept. 1988), p. 159.

Wooster, Ann-Sargeant. "A Celebration of Liberty." *Amtrak Express*, June–July 1986, p. 18.

Zimmer, William. "Enigmatic Interiors at Noyes." *The New York Times*, Aug. 25, 1985, p. 20.

_____. "A Quietness Pervades Surreal Works by Three Photographers." *The New York Times*, Feb. 26, 1989, p. 22.